CHARLOTTE

CHARLOTTE
MURDER, MYSTERY AND MAYHEM

DAVID AARON MOORE

Charleston London

THE
History
PRESS

Published by The History Press
Charleston, SC 29403
www.historypress.net

Cover design by Natasha Momberger

First published 2008

Manufactured in the United States

ISBN 978.1.59629.490.5

Library of Congress Cataloging-in-Publication Data

Moore, David Aaron.
 Charlotte : murder, mystery and mayhem / David Aaron Moore.
 p. cm.
 Includes bibliographical references.
 ISBN 978-1-59629-490-5
 1. Crime--North Carolina--Charlotte--History. 2. Crime--North Carolina--Charlotte--
Case studies. 3. Murder--North Carolina--Charlotte--Case studies. 4. Charlotte (N.C.)--
History. 5. Charlotte (N.C.)--Social conditions. I. Title.
 HV6795.C396M66 2008
 364.9756'76--dc22
 2008032144

Notice: The information in this book is true and complete to the best of our knowledge. It is offered without guarantee on the part of the author or The History Press. The author and The History Press disclaim all liability in connection with the use of this book.

In memory of Dorothy O. Moore
1927–2007

CONTENTS

ACKNOWLEDGEMENTS

Thanks to the Robinson-Spangler Carolina Room of the Public Library of Charlotte and Mecklenburg County, with special acknowledgment to Joyce Reimann, Shelia Bumgarner, Jane Johnson and Gerri Blenman. At the *Charlotte Observer*, my thanks go to Maria David and Don King. Big props and a tip of the hat go to *Charlotte* magazine editor Richard Thurmond and former *Charlotte Weekly* editor Linda Singerle. For assistance in research, I offer my sincerest gratitude to Linda Paris. Somehow, "thank you" seems inadequate when I say those words to Bain Cannon for sticking by me and being supportive during the entire process—you've been a rock!

INTRODUCTION

Charlotte is my hometown. I grew up here and have always been aware of its rich history—both in achievement and, on a darker note, the existence of such things as you will find in this book.

I left this city for several years to explore what life was like in other places, but I found myself drawn back just after the turn of the twenty-first century. The Charlotte I left behind in the late 1980s was not the same place I found on my return. It had grown by leaps and bounds. Well over a million people now populate the city and the surrounding metro area. Indeed, it is today the fastest-growing city in the country.

Coming back to live in my birthplace has afforded me a unique perspective: I remember what was, what is no longer and what has survived alongside the rapid-fire expansion over the past two decades. In my mind's eye, I can still see a litany of unusual events and a cast of characters that populated the city in the mid- to late twentieth century, many of whom are long-since gone, with the only trace remaining on black-and-white reels of microfilmed newspapers in the public library.

There are many wonderful things that have occurred in this city's lengthy history, yet there are other things not so delightful. Scandalous, gruesome, horrifying, mystifying, frightening, disastrous and corruptible—all adjectives that are appropriate when looking at certain aspects of Charlotte.

It was my knowledge of the city's past that prompted me to write an article for *Charlotte* magazine in 2003. "Charlotte's Most Notorious Crimes and Murders" looked at what I knew from my own personal knowledge and what I was able to glean from research in the clipping files at the Robinson-Spangler Carolina Room of the Public Library of Charlotte and Mecklenburg County. Much of that material was also found later in another title published by The History Press, called *Wicked Charlotte*, written by Stephanie Burt Williams.

INTRODUCTION

I realized I faced a dilemma when approached by The History Press to create this book: what I had uncovered in 2003 had already been presented in book form, so I had to go back to the drawing board and dig up other true tales of murder, mystery and mayhem.

I tried to go through the local police department, but records prior to the 1960s are fragmentary, I was told. A handful of people along the way shared some of their recollections and another crime and history buff let me take a look at her clipping file, which included some stories that dated back to the nineteenth century.

But that simply wasn't enough. Since the *Charlotte Observer* and its former sister publication the *Charlotte News* are not archived prior to the late 1980s, there was no way to search through their files for specific lurid tales of disaster and woe.

My breakthrough on this project came when I gained access to a website that archives more than 750 newspapers, some dating back to the 1700s, from here in the United States and around the globe.

No Charlotte newspapers are included there. At first I thought the site would be of no use to me. But then it dawned on me: if something particularly horrific or extremely out of the ordinary took place in Charlotte, chances are it would be picked up by other papers that were indeed archived. After many hours doing searches using various calamitous words and phrases, along with the city and state name, I was able to come up with a multitude of long-forgotten stories of disastrous events, horrific homicides and unsolved and mysterious occurrences, all of which took place in the fair Queen City.

How ironic, I thought, that in years past Charlotte was often referred to as the "City of Churches." This is purely conjecture on my part, but one wonders if perhaps the need for spiritual guidance grew out of fear of the surrounding violence.

Another curious point of fact, especially for a city of its size, Charlotte was named the murder capital of the state and the nation on several occasions during a thirty-year period from 1950 to 1980. According to a report released by the FBI in 1952, Charlotte led the state in crime by an overwhelming margin. Another such report, released in 1971, confirmed that Charlotte led the entire country with a higher murder rate per capita than any other city in the United States.

This book is not an effort to paint Charlotte as the crime capital of the country; rather, it is an effort to look at some of the more notorious aspects of the city's culture that have existed side-by-side with successful commerce, open-minded citizens and a warm culture full of friendly and progressive people ready to welcome you into the fold.

Introduction

With the advent of a booming population of new arrivals from around the globe, mixed with generations of families that have called the city home for centuries, Charlotte is a wondrous place to live.

But for some people that wasn't always the case.

Much like many other American cities of the early to mid-twentieth century, you'll find intolerance to minorities from all walks of life and miscarriages of justice that today would be deemed unthinkable.

A thought that a teacher shared with me sometime back in the early eighties sticks with me to this day. I think this sums it up succinctly: "How can we know where we're going without knowing where we came from?"

At times—during the process of writing this book—I was both exhilarated and horrified by what I discovered. Emotions aside, it was a fascinating journey to watch a city grow from its infancy to what it is today by uncovering some of its dubious past.

I hope you enjoy the read.

THE SAGA OF BENNY MACK

Some months ago, more than a year in fact, Charlotte nighthawks stood on the streets with their mouths wide open and gazed in amazement as a trim-looking youth socked and socked and at each sock an opponent went down. Finally, however, the youth was forced to concede victory to the continuous line of reinforcements. That youth was Benny Mack, the Charlotte boxer who many people believed would be unable to break an egg with his blows.

— Text from an unidentified Charlotte paper sometime in the late 1920s, reprinted in the Shelby Daily Star, *April 1, 1961.*

His name was Elijah Ben Quinn McIntyre. He was born in 1903 in McDowell County to Jeremiah Francis and Myra Harris McIntyre. As a child growing up in Rutherford County, he was attacked by a rabid dog and infected with the virus that invariably leads to acute encephalitis, madness and—in most humans—death. As there was no cure for such an infection in those days, McIntyre was chained to a tree and left in a thrashing rage. Miraculously, he recovered, perhaps becoming one of the few known cases in history to survive a rabies infection without treatment.

As a teenager, he served the then-requisite military period—doing a stint in the navy just after World War I. It gave him a chance to see some of the world and hone his boxing skills.

Afterwards, McIntyre returned to North Carolina and moved to Charlotte in 1922.

In 1927, he married his first wife, Virginia, in a ceremony held on June 5, in Chester, South Carolina. The two came back to Charlotte and, less than a year later, Virginia gave birth to a daughter they would name Bennie Sue, in honor of the aspiring father.

It was here in Charlotte that McIntyre was able to indulge his passion of boxing. Standing at just five foot four and weighing less than 140 pounds, he was a diminutive yet wiry young man and was categorized as a "welterweight" or a super lightweight. He quickly rose from an unknown street boxer to a pro—now going by the name Benny Mack—and capturing the headlines: "Mack Defeats His Opponent By Knockout," "Mack Signs For Bout On Local Card" and "Bennie Mack Is Semi-Final Winner."

It was also here that an event occurred that would forever change McIntyre's life and end the life of another man—Charlotte landscape gardener William Moore.

Newspapers announced the story of how Moore was shot in the back over an argument relating to an unpaid debt of five dollars for a bulldog he had purchased from McIntyre. McIntyre confessed that he did indeed shoot the man, but claimed it was in self-defense.

Despite his claim, he was charged with first-degree murder. The trial began on February 26, 1929, and Charlotteans were riveted. Presiding over

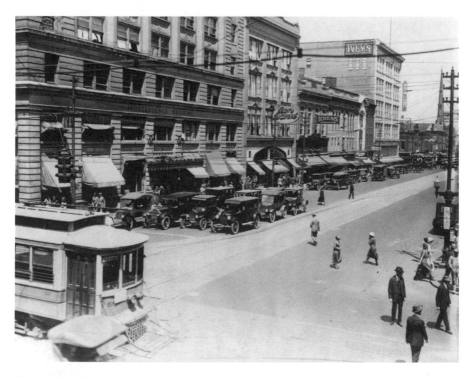

The Roaring Twenties in the Queen City: Benny Mack made a name for himself here through boxing and murder. *Courtesy of the Robinson-Spangler Carolina Room—Public Library of Charlotte and Mecklenburg County.*

the case was Judge A.M. Stack, a man known for his Southern traditionalist views and conservative religious convictions.

Witness after witness would take the stand. Most damning was the testimony of the victim's brother-in-law, Dillard Price, who provided his version of a firsthand account of what occurred. According to Price, he and his brother-in-law were walking along the Concord Highway on February 3 at the same time McIntyre was driving by. McIntyre stopped his car and called Moore over to speak with him. Price said he overheard McIntyre ask Moore when he was going to pay him the five dollars he owed him for the bulldog he'd sold to Moore a few weeks earlier.

"I'll pay you Monday," Moore reportedly said.

"You're going to pay me now," McIntyre replied.

Moore turned to walk away from the confrontation and McIntyre opened fire, shooting Moore in the back—not once, but three times. One entered Moore's left side between the fifth and sixth ribs, another pierced the spinal cord at the back of his neck and the third entered the chest two inches below the nipple, penetrating the lung.

McIntyre's version of what happened is somewhat different. He claimed that Moore drew a pistol on him first and that he only fired in self-defense. In his testimony, McIntyre recalled encountering Moore on the Thursday prior to the incident and questioning him about the five dollars. He said that Moore cursed him, laughed and then drove away in his car. "God damn you," McIntyre recalled Moore saying. "Come on out here and I'll settle now for that dog. I'm going to kill you yet about that dog, you son of a bitch."

McIntyre confirmed he was shaken up about the encounter, and when he ran in to him days later, he called out, "What did you say, old boy?"

"God damn you poor soul," Moore reportedly replied. "I told you I would pay you for that dog." McIntyre insisted that Moore then leveled a pistol at him and he had no choice but to fire in self-defense.

Two days later, on February 28, McIntyre was convicted of second-degree murder and was sentenced to twenty to twenty-five years. As he was led away from the courtroom, he encountered Price, and a slew of angry verbal threats ensued.

"God damn you," he said to Price. "I wish to God I had killed you and your whole damn family and had gone to the electric chair."

Judge Stack immediately hauled McIntyre back into the courtroom.

"Now young man, you think you're bigger than the law and you can say what you like?" Stack asked.

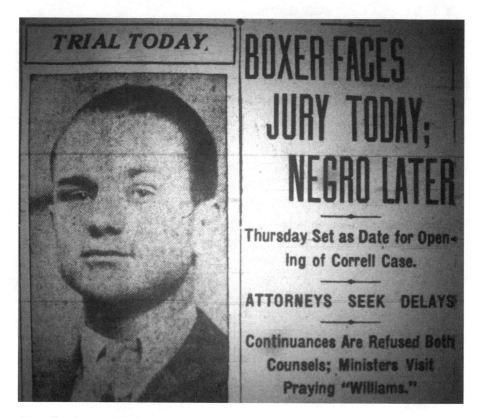

TRIAL TODAY.

BOXER FACES JURY TODAY; NEGRO LATER

Thursday Set as Date for Opening of Correll Case.

ATTORNEYS SEEK DELAYS

Continuances Are Refused Both Counsels; Ministers Visit Praying "Williams."

A headline from the *Charlotte Observer* just days before boxer Benny Mack would go on trial for murder.

"No your honor. I don't think I'm bigger than the law," McIntyre replied. "You would have said the same thing I did if Price and the others were swearing the lies they did."

Stack turned his attention to the clerk of court: "Clerk, strike out the first sentence and make it read, not less than 22 years and not more than 30." Stack then launched into a holier-than-thou tirade about the evils of boxing:

> *Prize-fighting is nothing but fighting that has been legalized. There is not a boxing match that doesn't diminish respect for the law. I think I see its evil effect on the young men and boys growing up. The moving pictures are doing the same thing.*
>
> *A boxer, like Benny Mack, has his instinct developed for pugnacity. Why, up in Shelby the other day another fighter killed a man, too. It's a felony to fight in North Carolina outside of Charlotte, Greensboro,*

Raleigh and some other cities. Down here they get in a ring and pummel each other. That destroys a man's idea of things.

This killing by Benny Mack was wholly inexcusable. There was no earthly grounds for it. It looks like a pure deliberate slaughter of a man.

In what may have been a coincidence, or perhaps gifted insight, Stack went on to further lament the difficulties in convicting a well-known figure.

"It's hard to convict a man with a following," Stack continued. "His friends trot down to the governor for a retrial. I've sentenced many people who have never served a day."

McIntyre did, in fact, serve slightly less than three years. It wasn't his friends who trotted down to the governor's office, however. It was McIntyre's grandmother, Mary Jane Gardner, who convinced her cousin, then-governor Max Gardner, to pardon her grandson.

By early 1933, McIntyre was released and ready to take on the world again. This time he set his sights on Hollywood, leaving behind his wife Virginia and daughter Bennie Sue in Charlotte.

Arriving in California sometime in late 1933, McIntyre secured work as a stunt double for James Cagney, stepping in for the tight spots in films like *Winner Take All*, *The Irish in Us* and *The City for Conquest*. He reportedly developed a friendship of sorts with actress Ginger Rogers and eventually landed a position as fitness instructor at MGM.

He didn't give up boxing entirely during his time in Hollywood. According to records at the World Boxing Association, Benny Mack went head to head with hard hitters Angus Smith (in Ventura on May 3, 1935) and Wally Hally (at Legion Stadium on June 21, 1935).

He lost both fights and there are no other recorded match dates for McIntyre following those two.

On June 25, 1937, Virginia G. McIntyre sued her absent husband for divorce. In documents filed, it's clear that she had no contact with her husband for a few years. Furthermore, the documents indicate, authorities were unable to ascertain Benny McIntyre's whereabouts and that he could not be located within the state of North Carolina. She retained custody of their daughter, Bennie Sue.

Although what exactly occurred over the next five years of McIntyre's life is unclear, surviving relatives later confirmed that it was during this period, more than likely, that he left Hollywood and became involved in the shadowy underworld of Chicago gangland crime and violence. Although McIntyre never confirmed any specifics, he admitted to working with Al Capone and that he had killed again, after William Moore.

Perhaps it was because he was running from something, or maybe he was just tired and felt like it was time to go home. Whatever the case, McIntyre returned to North Carolina and took up residence in Rutherford County in the early '40s.

Now forty, he married his second wife, fifteen-year-old Mary Sue Lovelace.

"When he came back here he was one of the very few people around to have a car," says Benny McIntyre Jr., who agreed to be interviewed about his father. "She was young, but he had a suit and a car so he was viewed as good material to marry her off to back in those days. Today he would probably be arrested!"

Over the next twenty years, McIntyre raised a family with his young wife, leaving behind old ghosts and holding down a regular job. For the most part, everything went smoothly. They had six children together—Jerry, Steve, Martha, Trudy, Bennie Sue and Benny Quinn Jr. Two other children died at birth.

"Yes, I was the second Bennie Sue," said daughter Bennie Sue Howard (also interviewed), recalling her father. "I never knew the first one. My dad didn't know what happened to her for sure either, but he did go back to Charlotte a few times to try and find her. He always wanted to let her know that he loved her and was sorry how things turned out. As far as I know, he never saw her again."

According to the Internet Movie Database and a listing from a television section of a newspaper, it appears that sometime during 1960 or 1961, McIntyre may have returned to Los Angeles briefly for a few small television roles. Acting under the name Mark Tanny, he purportedly played the role of a ticket clerk in an episode of the fledgling ABC series *My Three Sons*, entitled "Bub Leaves Home."

In a very short-lived ABC series called *The Roaring Twenties*, his appearance in the program actually prompted enough attention to garner a short blurb in the *Fresno Bee*:

Ex-Pugs Play Thugs

Hollywood—Slapsie Maxie Rosenbloom, former world light-weight champion, and Benny Mack, one time welterweight prize fighter, play muscle men in "Asparagus Tipps" on ABC-TV's "The Roaring Twenties." Mack, acting under the name of Mark Tanny, formerly was athletic director at MGM.

Murder, Mystery and Mayhem

This fact is disputed by Howard, who says she can't recall him being absent during that period for any length of time. Benny Jr. sees it as a distinct possibility, however. "I wouldn't be surprised," he says with a chuckle. "He always had something going on. It's entirely possible that he did go away for a few days and didn't tell my mother anything other than just he was going away for work. I guess we'll never really know."

Whether McIntyre stole away for a few days in late 1960 or early 1961 to film a couple of bit parts for some extra money or someone else was trying to cash in on his former notoriety is uncertain.

One thing that is clear, however: everything started to fall apart in 1961. Since he had returned to the Rutherford County area some twenty years earlier, he had worked as a used car salesman. With six children to feed by 1961, there just wasn't enough money to go around.

A few weeks later, desperate to get money for his family but too proud to turn to charity for help, he attempted to sell his life story to the *Shelby Daily Star* for $500. They turned him down, telling him it just wasn't that interesting.

On March 21, now at the end of his wits and obviously showing the signs of mental degeneration, he marched into the Marion Bank & Trust Company, undisguised, and robbed it of $3,641. During the process, he herded three employees and four customers into a back office and then forced a bank officer to fill a paper bag with cash. He escaped with the money on rain-slick streets, but was later identified, picked up and charged with armed robbery. Headlines read: "Ex-Pug Charged in Bank Robbery."

Tried and convicted in Asheville and sentenced to fifteen years in prison, he was sent to the Atlanta Federal Penitentiary.

"After three weeks it became clear to all the people around him that my father was mentally ill," says Howard. He thought everybody was a communist and they were all trying to kill his family."

"He was diagnosed with pugilistic schizophrenia," says Bennie Jr. "All those years of boxing damaged his brain."

In the years that ensued, McIntyre was moved from hospital to hospital until finally his wife Mary reached out to Senator Robert Kennedy, who intervened and had her ailing husband moved to Broughton Hospital, a state-owned mental care facility in Morganton, where he was eventually allowed to return home for brief visits.

"He would come home after being in the hospital for some time, getting good care and the proper medication," says Benny Jr. "But after a while he would decide that he was fine and he didn't need his medication anymore. After the effect of the meds wore off, he would start acting strange again and

it was apparent that he was mentally ill. Inevitably he would always have to go back to the hospital."

On one of his last visits home, he became disoriented and wandered away from home. He was picked up by police, who recognized him immediately and returned him to his residence.

It was his daughter Trudy that would take him back to the hospital that time.

"It was the last time I saw him," says Benny Jr. "All I can remember him saying to me before he left was 'Be good.'"

Unbeknown to Trudy, her father had concealed a weapon. When they arrived back at Broughton and met with a staff member, all hell broke loose.

"The doctor put his hand on my dad's shoulder, to reassure him in a friendly manner," Howard says. "But in the state of mind my father was in, he thought the doctor was trying to hurt him. He pulled out this knife and stabbed the doctor in the stomach."

The doctor survived and McIntyre would receive treatment, though he did not leave the hospital to visit with his family again.

The little man who made big headlines in the Queen City saw his final day on August 14, 1973, when he died of natural causes in Broughton Hospital. He was laid to rest in a solitary grave site at Piney Knob Cemetery in his beloved Rutherford County.

RAZOR GIRL

She was born Nellie Ellis Green on October 31, 1906, in Rutherford County to Robert Green and Junie Etta Bridges. For a brief period in 1926, she would make all of Charlotte stand up and take notice.

It was her marriage to Alton Freeman, and the outcome of that union, that would thrust her into the public spotlight. Alton was the son of farmer Adolphus Freeman and his wife Nannie. Born in Berryhill Township in 1903, he was the youngest—and clearly the most spoiled—of all the eight Freeman children.

Exactly how Nellie and Alton met is unknown.

What is known is that they were briefly married, around five months, beginning sometime in late 1925 and ending abruptly on the evening of May 22, 1926, when Nellie admits that she killed Alton—albeit accidentally, she claims—by slashing him in the throat and nearly decapitating him.

Before things all came to a head, Nellie had been working at Nebel Knitting Mills, where she worked up to ten hours a day, bringing home less than fifteen dollars a week, much of which Alton would take from her.

According to Nellie, Alton had been chasing other women, refusing to find a job and was planning to leave her. A convicted auto thief, he announced that day that he was going to steal some whiskey to fund his getaway from her. Although it never came up during the trial, Nellie confided later in life that Alton was also attempting to force her to sleep with other men to bring in more money.

Nellie insisted she loved Alton despite all of his shortcomings. Both Alton's mother and Nellie attempted to dissuade the young man from his plans, to no avail. When she was alone with Alton, she once again begged him to stay. When he rebuked her advances, she pulled out a straight razor and took a swipe at his throat. She claimed she didn't know how sharp the blade was, and only meant to scare him and teach him a lesson.

Nevertheless, the turbulent life of one Alton Freeman was snuffed out in one deft swoop.

Police arrived to find him in a pool of blood, dying in his mother's arms in the kitchen of the house on Camp Greene Street. According to reports, he was nearly decapitated.

What followed could only be described as a circus.

America in the 1920s saw women as inferior and weak-minded, given to sudden fits of hysteria and bouts of insanity, therefore not in control of their own faculties. How could a small-minded, weak individual be held responsible for such an act?

Ironic that Nellie's first words to police when they arrived upon the scene were "I'm 19 years old and I weigh less than 90 pounds." Another point in her favor was that the thought of executing a woman, especially a white woman, was seen as particularly abhorrent.

Nellie would spend the next two months in jail before announcing her plea of not guilty and finally going to trial in mid-July 1926.

During the trial, Nellie was seen laughing and joking with reporters and her attorneys. Public fascination around her grew rapidly as she became an instant media celebrity. The *Charlotte News* and *Charlotte Observer* take up her cause in earnest, labeling her "pretty little Nellie Freeman," "the childlike murderess" and "the forlorn, little waif."

Attention was shown to nearly every detail of Nellie Freeman, even down to her choice of fashions: "Neatly garbed in a white dress of some attractive design with a close-fitting, orange-colored hat and...scarf to match... looking unusually dainty in her white dress, silk scarf and chic new pink hat." Obviously, both the press and the public were smitten with Nellie.

Said a report from the *Charlotte News*: "Public Sentiment was not aroused in indignation, but rather took the turn of a sympathetic wonder at what a girl would do in an effort to relieve the situation. None condoned her act as justified, but her petite frame and audacity stood her in good steed, as far as the man on the street was concerned."

In addition to being a car thief, it was also revealed that Alton had been married twice before and never divorced.

During the trial, Nellie's attorneys brought in psychiatrists to testify that Nellie was not guilty by reason of temporary insanity. Dr. John Davidson declared that she "has the mind of a six-year-old child." Other doctors confirmed "evidence of hereditary insanity." Further holding up their case, defense attorneys claimed that even though she seemingly grasped the English language, she was totally ignorant of arithmetic, which was evidence of "a lack of originality [and only] a parrot like mechanical ability."

Murder, Mystery and Mayhem

From upper crust society to her fellow mill workers, the spectacle continued as masses poured into the courtroom to watch the testimony unfold. Courthouse vendors sold tiny commemorative gold-plated razor pins with Nellie's name emblazoned on them. "The blade is movable, as is appropriate with a Nellie Freeman razor, and swings loose."

Ten days after the trial began, the jury returned with a verdict of not guilty. Church workers and wealthy philanthropists rallied to Nellie's aid in an effort to help her begin life anew.

Prosecutors, however, didn't buy the claim of insanity.

"I think the killing of Alton Freeman is one of the most flagrant, most volatile in my experience," said prosecutor's assistant J.D. McCall. "Their verdict was laughable and ridiculous. There was no excuse for the slaying, whatever…if women like her are turned absolutely loose on the public, no man is safe."

Afterwards, Nellie sent word to presiding Judge Michael Schenck.

"I want to keep the razor and the dress," she reportedly said. "But I don't want to talk about the trial anymore. I want to forget, if I can, the painful incidents of the past two months, and talking about it only recalls it to mind. I hope the Freemans didn't feel too hard towards me. I didn't mean to do it."

And forget she did. For all intents and purposes, Nellie Freeman vanished into history. At least from the public eye. And despite J.D. McCall's claim that no man would be safe with Nellie free, she proved him wrong.

Within a matter of days, Nellie went to stay with relatives in Kentucky.

On October 26, 1926, Nellie married Samuel R. Hatley in Louisville, Kentucky. For a while, they made their home in Concord, with Samuel's parents.

They had their first son, Robert, on July 24, 1927.

"When they first got married my father was a weaver in a mill," recalls Robert Hatley, his voice cracking as he remembers those difficult early days during the depression. "We moved all over the place because he had to go where he could find work. We lived in Ranlo, Kings Mountain and Cherryville."

By 1930, the family would be back in Charlotte, living off State Street in the Wesley Heights neighborhood. Two other children would follow, both sons—Tim in 1930, and Merle in 1936.

The woman who once attracted so much attention as Nellie Freeman, the notorious "Razor Girl," now wanted nothing more than a quiet life with a loving husband and family. She even told the 1930 census taker that her marriage to Hatley was her first, and her maiden name was Ellis, rather than Green—she made no further reference to her former married name.

25

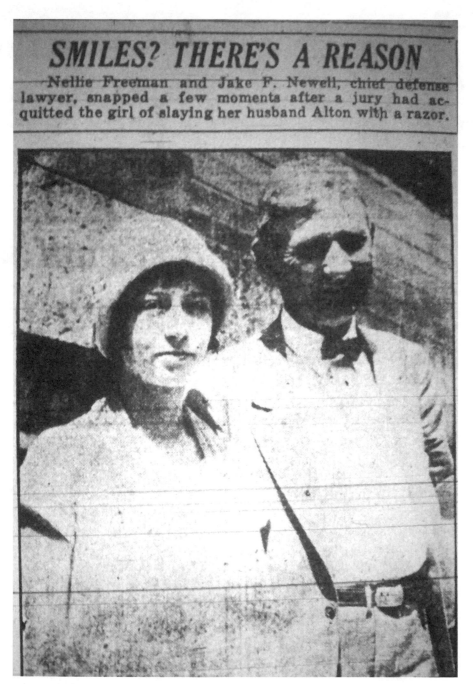

SMILES? THERE'S A REASON

Nellie Freeman and Jake F. Newell, chief defense lawyer, snapped a few moments after a jury had acquitted the girl of slaying her husband Alton with a razor.

The "Razor Girl" slaying played out in the pages of the *Observer* over several weeks, bringing sensationalized news to Charlotte's residents. In the end, jurors found Nellie Freeman not guilty.

"You couldn't have had a better mom," says Robert. "She took us to church every Sunday. She would take us for trolley rides."

Despite the passage of time and the change in location and name, not everyone forgot about the spectacle surrounding the death of Alton Freeman. "One day I was playing outside and another kid told me that my mother had killed somebody," Robert recollects. "I asked her about it and she said I was too young to understand and that she would tell me about it someday. She never did. She just didn't want to talk about it."

Robert would never know much of the details of his mother's life before marriage to his father until after her death.

At the age of sixty-four, on May 22, 1969, Nellie Ellis Green Freeman Hatley would die of congestive heart failure in Charlotte's Mercy Hospital. She spent more than forty happy years with Samuel Hatley, and never hurt another soul.

And despite the fact it was Nellie's hand that took Alton's life, she apparently maintained a relationship with his parents well after his death.

"She would take us to visit this elderly couple in the North Davidson area on the trolley," says Robert Hatley. "I remember we visited a few times. It was always as though she wanted to show them the children she had and the life she had. I never knew their names, but there seemed to be a genuine affection between them. I'm convinced that was the Freemans."

And, as it turns out, there were more forces than just the press, the public, the jury and the defense attorneys on Nellie's side.

"Daddy told me while she was in jail that she said somebody came to visit her one night and asked her to tell him everything that happened," Robert says. "She couldn't see who it was because he sat back in the shadows. She thought she recognized the voice, though."

It was only back in the courtroom that Nellie realized who had come to talk with her the night before: former Charlotte Judge Michael Schenck, who presided over the entire case.

THE MAUSOLEUM MURDER

Foy Belle Dixon grew up in what was once known as Berryhill Township, which was later incorporated into the City of Charlotte and today lies west of Tuckaseegee Road, stretching across Freedom, Wilkinson and beyond. Born into a community of farmers and millworkers in 1880, Foy was the second child for Annie and Joseph Dixon, who would have a total of four children.

Had Foy's father not died unexpectedly sometime in the late 1890s, chances are there would have been more siblings. In farming families of the period, it was not uncommon to have upwards of ten or more children. But fate would deal a cruel blow to Annie Dixon, leaving her a widow charged with the raising of the four children. Foy was the oldest girl, and a special bond grew between mother and daughter as she helped raise her two younger siblings.

In her mid-twenties, Foy Belle Dixon met and married Charles Cooper. By this time, Annie and two of the remaining children had left behind the rural life for a residence in Charlotte's Third Ward. Charles was a bricklayer and Foy took up dressmaking. They moved into the Third Ward as well, to be close to Foy's mother.

In 1908, they had their first and only child, Frederick Joseph Cooper. For the next ten years or so, life for the Dixons and Coopers went fairly well. Then tragedy struck again when Charles died, leaving Foy to raise young Frederick.

Foy was devastated by her loss, but she faired better raising Frederick than Annie had with Foy and her other brothers and sisters. Like her mother before her, she would never remarry after Charles, but at least she had family close by to help bring up young Frederick.

Annie would remain a strong figure in the Dixon and Cooper households for many years to come. In fact, Frederick was thirty-seven by the time his grandmother died in 1945 at the age of ninety-three.

Foy was now sixty-five and living alone, still in the Third Ward house she and Charles had moved into decades earlier. Frederick would come to visit often with his wife Juanita and their newborn daughter, Jo Ann. That gave Foy a chance to dote on her granddaughter and provided her with some consolation, yet she never fully recovered from the loss of her beloved mother. In an effort to fill the void left behind by her mother's death, she would frequently visit her grave site, which was just a few blocks away in nearby Elmwood Cemetery.

The walk to Elmwood became a regular routine for Foy. She felt comfortable in her neighborhood, and enjoyed the daily strolls she would take with her little dog, who had been her constant companion for fifteen years. Oftentimes she would take along lunch to enjoy in the sunny garden-like atmosphere of Elmwood Cemetery. Surrounded by massive oaks and a bevy of stunning sculptural headstones, the atmosphere no doubt helped her feel closer to the mother she so loved.

But as Foy grew older, the climate of the neighborhood began to change.

By the late 1950s, Elmwood, as well as the neighboring Pinewood Cemetery (which, at the time was reserved for the city's African American residents), had become havens for the homeless and criminals who used the cemetery's benches to hang out, sleep, broker deals and drink.

At seventy-eight, in 1959, Foy was unperturbed or perhaps unaware of the dangers that might await a vulnerable elderly woman.

On Sunday, September 20, Foy would take her last walk to Elmwood Cemetery.

According to a neighbor, Cooper left her home in the Third Ward sometime after 1:00 p.m., with her small canine companion in tow. The walk to her mother's grave site generally took only a few minutes, but Foy's pace had slowed down a bit in the past year or so.

It also appears that she decided to run a few errands along the way. A store owner told the police that Cooper stopped by his store to drop off a carton of empty soda bottles before heading in the direction of the cemetery.

In all probability, she arrived at her intended destination—a carved stone bench by her mother's burial plot—sometime just before 1:30 p.m.

Witnesses on the scene at the cemetery that day reported hearing a dog let out a single yelp sometime after 2:00 p.m. A young boy reports seeing a man crouched in an overgrowth behind the bench where Cooper often sat around the same time.

Sometime within the next fifteen to twenty minutes, she was attacked.

Foy may have been elderly, but police accounts confirm that she didn't go down without a fight, and a brutal one at that. Initial reports from the

Murder, Mystery and Mayhem

Charlotte Observer and *Charlotte News* offer this probable scenario: snatched from the bench where she sat, she was pummeled and beaten, raped, strangled to death, dragged over a fence and down a slight incline and then stuffed into a mausoleum in Pinewood Cemetery.

A coroner's report would later indicate that her body was covered with bruises, and she had a laceration on her head, possibly a fractured skull and rope burns around her neck. A later autopsy revealed a brain hemorrhage and heavy bleeding from throat tissue.

With forensics limited to the technology of the time, there was rampant speculation as to whether or not she was killed outside and placed inside the crypt post mortem, or left to die inside the darkened and gloomy mausoleum.

Whatever the case, it would only be a matter of hours before her lifeless body would be discovered.

Three young boys—Ronnie McCauley, Steve Cowick and Dale Jackson —had come to Elmwood Cemetery like they did almost every Sunday after church to run and play and chase away chipmunks and squirrels with sticks.

Shortly before 5:00 p.m., they were joined by another group of young boys who, spying the hole in the door of the crypt, dared McCauley, Cowick and Jackson to venture inside. Jackson recalled part of the experience in a brief interview with the *Charlotte News*:

> *We went yesterday, and after a while* [another] *group of boys showed up. One of the boys hollered at Ronnie, "I bet you won't go in there to meet...Dracula!"*
>
> *Ronnie stuck one* [arm] *and his head through the door and started hollering, "There's a real dead woman in there!"*
>
> *We didn't believe him, so we took a peep. When we saw her, it scared us to death. I had a stick in my hand and Ronnie took it and went back to the hole. He poked the woman to see if she was dead or just sleeping. When we found out she was dead, we ran up a hill...to tell police.*

"We ran to a telephone," McCauley told the *Charlotte Observer*. "I called the operator and asked for the number of the police. I dialed the number she gave me but a taxicab company answered. It was my last dime. Just then a police car passed and we ran it down."

Within minutes, several policemen arrived on the scene and a crowd of onlookers started to gather. Police had to push the crowd back in order to

31

break open the door of the crypt to gain access to Foy's body. The scene they encountered was gruesome: blood stained the marble inside the Jones family mausoleum. A sleeve of a sweater she had been wearing was crammed in her throat; the other was wrapped tightly around her arm.

As for the canine that had been Foy's companion so many years, he, too, would die that day. The little dog was found dead, lying on top of Annie Dixon's grave just a few hundred feet away. There was no evidence that the dog had been beaten in any way. Strangely enough, though, someone had arranged small sticks in a pattern around his body.

Was that someone the same perpetrator who had killed Foy? Does it make sense that, after raping and killing Foy, he would come back, possibly suffocate the dog and then arrange a decorative pattern of sticks around it? Was the yelp heard after 2:00 p.m. that of Foy's dog's last breath?

Police speculated that the dog "died of fright."

The body of Foy Cooper was removed to a local funeral home. Identification was made an hour later by her son Frederick, who confirmed he had been attempting to reach her by phone all day. After hearing reports on the radio, he contacted police for fear it might be his mother, since she made almost daily visits to Elmwood.

Charlotteans were horrified.

The police swept the cemetery looking for possible clues. Within hours, they began rounding up possible suspects—looking at many of the men who used Elmwood as a hangout.

The following evening, they arrested thirty-two-year-old Elmer Davis Jr. in Belmont. Davis had arrest records dating back seventeen years, and had been in and out of trouble with the law since that time. He had recently escaped from prison, where he was serving a sentence of fifteen to twenty years on a conviction of assault on a female, robbery and attempted rape.

"It was a case similar to Mrs. Cooper's death," Detective Lieutenant J.A. Gilleland told the *Charlotte Observer*. "Davis attacked an elderly woman near a creek here in 1950." Over the next few days, police would find various parts of the puzzle: Foy's hair net was discovered behind a tombstone. Her purse was found wrapped in a newspaper, hidden behind some hedges. A length of rope was also discovered in the cemetery.

Outside Pinewood on the 400 block of West Eighth Street, police discovered blood-stained clothing that they theorized may have belonged to the killer.

Clearly Frederick was crushed by the loss of his mother. He was her only child. Perhaps in an effort to put the pain behind him, he moved forward with funeral plans quickly. Foy was buried just two days after her murder, and in all likelihood, mere feet from where she actually met her demise.

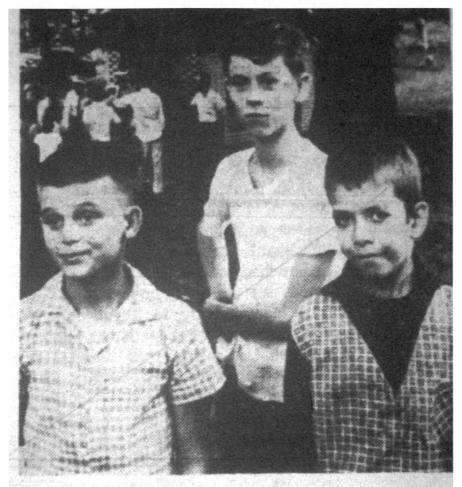

THEY FOUND BODY — Ronnie McCauley (center) of 124 S. Cedar St. crawled into mausoleum on a bet from Steve Cowick of 112 S. Cedar St. and Dale Jackson of 719 W. Trade St. (Observer Photo—Roberts)

This cover image from the *Charlotte Observer* shows the young boys who discovered the body of Foy Cooper in an old crypt.

It was announced by police through the press that the chief suspect in the case was now Davis. A number of other men had been rounded up, questioned and later released. Davis was on the top of the list for two reasons: the earlier, similar conviction, and because he could be connected to being present in Elmwood Cemetery on September 20.

When he was initially arrested, he had in his possession identification papers for a man named Bishop Buren Hayes. Hayes would later testify at trial that his billfold and shoes had been taken from him while he lay in a drunken sleep at Elmwood on September 20.

In Davis's defense, it would be remiss not to point out that he didn't exactly come into the world with a silver spoon in his mouth.

He grew up just a few blocks from the Coopers, but while Foy had the support of family so close, Elmer was being introduced to a decidedly different side of humanity. He was just seven when his mother murdered his father on January 13, 1934. Less than eight years later, the disregard for life that he had been exposed to when he was just a child perhaps led him to begin his own criminal career while still just a young teenager.

By the age of fifteen, he was already serving his first prison sentence.

Although records from the time are fragmentary, Davis's life was a roller coaster ride of trying to survive during multiple stints in prison and life outside in a world that was less than friendly towards an uneducated and impoverished African American man.

What is known from existing records confirms that Davis had been in prison since the 1950 conviction, when he escaped from an Asheville prison camp. After his arrest for Foy Cooper's murder, he was held by Charlotte police for sixteen days in the city jail, customarily used for overnight detention only.

Following intense interrogation during that period, in which he was allowed to speak to no one, bathe only once and was fed minimum rations, he signed a confession.

According to police, after Davis and another officer "prayed together," he took the officers to the cemetery and reenacted the crime.

Davis denies this. He said he was told the following: "Davis, go in there and sign that paper so you can go to the county jail and get something to eat and get a hot bath." He further asserts that when he signed the document, he "did not think [he] was confessing to any crime." He also contended that he was illiterate, and that the document was not read to him before he signed it.

At trial in 1959, Davis's counsel objected to the admission of confession. It was accepted, nevertheless, and Davis was sentenced to die in the gas chamber.

He would repeal the case in 1962, 1964 and again in 1966 before the decision was reversed and eventually Davis was allowed to go free again.

Although all indications suggest that Davis made an attempt at a normal life outside the prison system, he was unable to stay out of trouble for long.

Murder, Mystery and Mayhem

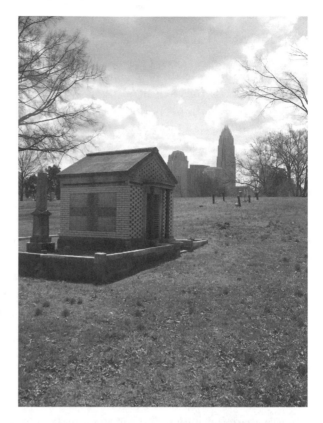

This page: Foy Cooper was visiting her mother's gravesite when an unknown assailant attacked and raped her, leaving her body stuffed in this old crypt in Pinewood Cemetery. She was laid to rest days later just feet from her beloved mother. *Courtesy of the author.*

Less than eight years later, he was arrested for felony larceny, convicted and sentenced to two years.

Again set free in 1976, he seemingly managed to lead a public life without problem until 1981, when he was arrested for felony breaking and entering and larceny. This time he was sentenced to five years, but was actually released after serving just two, in 1983.

More than a decade would pass this time before his next arrest, in 1996, once again for felony breaking and entering. Convicted and sentenced to just one year, he was released in 1997 and spent another year and a half free before his most recent conviction for habitual felony. Currently he is serving a seven-to-ten-year sentence and is expected to be released in 2009.

To date, Foy Cooper's tragic murder remains unsolved. Even though Elmer Davis's conviction was overturned in 1966 and he was subsequently released, police apparently felt confident enough about his guilt that no other suspects were sought. According to all accounts, at the age of eighty-one, he still maintains his innocence regarding the Foy Cooper murder.

On a visit to the Dixon-Cooper family burial plot today, one would discover the same bench Foy was probably seated on when she was first attacked, the headstones of her mother and a brother and sister to the left and those of her son and daughter-in-law to the right.

Without a doubt the most touching stone at the Cooper grave site is a single, square granite-cut foot stone at the bottom edge of Foy's final resting place. Placed by Frederick a few years after his mother's death, only one word is carved into the stone: Mommie.

FRANKLIN FREEMAN
Who Killed ReRe?

Franklin Freeman was an individual beset with conflicting drives and desires. On one hand, he was described by a coworker as "one of the most loving, caring individuals you'd ever meet." On the other, he was known to rob clients to whom he had provided his services as a cross-dressing prostitute.

Danny Watson was the owner of the pet grooming salon Posh Pets. He met Freeman when a coworker recommended him for a position at the salon. Watson knew that Freeman had difficulty holding down regular employment, but after he met him, he was determined to give Freeman a go at the job.

"He was one of the nicest individuals I've ever met," Watson recalls. "And actually a very good worker. He'd do anything you needed."

Although Watson didn't have any problems with Freeman's gender-bending fashion trends, he felt some of the customers were often thrown by Freeman's appearance.

"Somedays he'd come to work dressed as a woman. Sometimes he'd dress like a man. Other times he'd come in somewhere in between," Watson chuckles. "I told him it was okay to do either a man or woman, but I'd prefer him to stay away from that in-between thing. I think it rattled some of the customers. He was okay with it."

A devoted fan of Aretha Franklin, Freeman would occasionally lip-sync songs by the R&B diva at Oleen's, a now-defunct gay bar once located in Charlotte's Dilworth neighborhood. Performing under the name Aretha Scott, he would dress up in women's clothes from head to toe, usually wearing the highest heels possible. His friends often referred to him as "ReRe," a nickname he even had tattooed on his arm.

"Franklin's shows were unlike any other," recalls Lupie Duran, a friend of Freeman's and owner of Lupie's Cafe. "He didn't pull off being a woman as much as some of the other drag queens did. But he didn't care. He was just Franklin. And he was very funny."

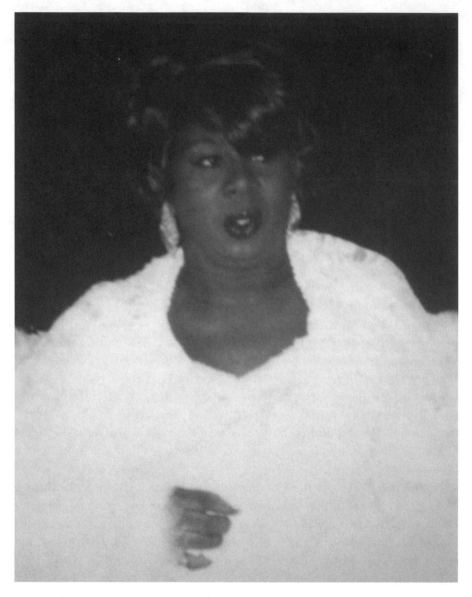

Franklin Freeman frequently performed in drag as Aretha Franklin at clubs around Charlotte. *Courtesy of Danny Watson.*

Duran initially met Freeman in her restaurant.

"There was something about the way he carried himself," she says. "The way he just busted up in a place. I knew he was the kind of person I wanted to meet. He didn't care if somebody looked at him funny. He was definitely one of a kind for Charlotte. He'd be all done up with lipstick and false eyelashes

and then he'd have this five o'clock shadow. He didn't care that he didn't pull off being a woman. I think he just enjoyed the outrageousness of it all. In many ways I think he really liked being tacky."

Despite Freeman's big city approach to drag—retro-comic gender-blending, as opposed to the look and feel of real in a red sequin gown—Duran says there was still a lot of the small-town boy under the urban exterior.

"In a lot of ways, he was really country," she recalls. "That old saying 'you can take the girl out of the country, but not the country out of the girl' applied perfectly to Franklin. He was a good person. I totally miss him."

Freeman was found shot to death Friday, June 7, 2002, at 10:30 p.m. at the corner of Church and Liddel Streets. A passing motorist had called 911 to report seeing a person lying by the road. When officers arrived, Freeman was unconscious and bleeding profusely. He died within minutes and was pronounced dead at the scene.

An autopsy report revealed that Freeman's death was the result of a gunshot wound to his leg that lacerated his left femoral artery and vein. The bullet initially pierced his upper left buttock, then moved forward and down, exiting his left leg and then entering his right leg, where it lodged in muscle tissue.

Freeman was born in Gaston County on March 27, 1967, to Johnny Lee Freeman and Reola Watson. He grew up in rural York County, South Carolina, where he left behind a deft impression on every individual he encountered.

"Whatever was on his chest, he'd say it," his younger brother Johnny Freeman said in an interview with the *Charlotte Observer*. "He didn't hold back."

At York Comprehensive High School, all the students knew who the openly gay, flashy and flamboyant Franklin Freeman was. According to classmates, he was often the target of gossip because of his sexual orientation and personal sense of style.

Freeman was oblivious to the world around him—he was true to himself and remained humorous, outgoing and comfortably feminine, despite the fact he was six feet tall and almost two hundred pounds.

By his mid-twenties. Freeman had moved around a good deal and eventually landed in Charlotte sometime around 1990.

Duran says it was shortly after this time that she developed a friendship with Freeman.

"We seemed to be at the same places a lot," she recalls. "Gallery openings, clubs. He was working at the Pewter Rose, and I would go there for brunch sometimes. He had quite a following at Pewter Rose."

It was common knowledge to Duran and others in the city's counterculture community that Freeman enjoyed partying, including heavy drinking and

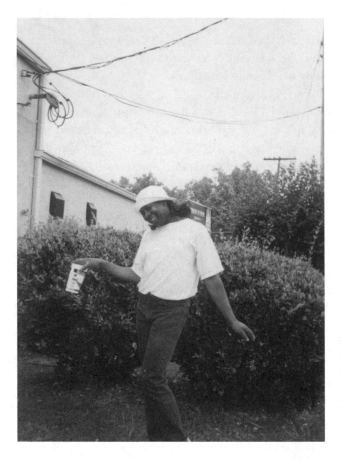

This picture of Franklin Freeman was taken at the dog grooming salon where he worked known as Posh Pets. He would be found dead within days. *Courtesy of Danny Watson.*

drug use. By the late '90s, Freeman had dropped out of the local scene, was reportedly turning tricks with frequency for money and couldn't keep a job. His biggest troubles, however, were still yet to come in a confrontation with an off-duty police officer.

What still remains an unsolved mystery but may have been the path that ultimately led to Freeman's death began on January 8, 2002, when Vice Detective Michael Marlow finished up his shift at 1:30 a.m. As he had done in times past, Marlow headed to the eighth floor of the policeman's parking deck for an after-work drinking party.

An article published in *Creative Loafing* indicates that such parties had been going on for years while administration apparently turned a blind eye.

Forty-five minutes after joining the rooftop shindig, Marlow left in his unmarked patrol car. Rather than head for home during the early morning hour, he drove to North Davidson Street, where he encountered Freeman on Twenty-fifth Street.

Here's where Marlow and Freeman's stories of what happened take diverging paths.

According to Marlow, a man jumped into his car uninvited after he saw him "waving frantically" and stopped to help. The officer said he and Freeman got into an argument and a physical altercation followed when he told the man to get out of his car.

A police-issued statement indicated that Marlow was the one who let Freeman, who was dressed as a woman and working as a prostitute, get into his car. It further states that Marlow fired in Freeman's direction during an argument over money and that Marlow then took beer from his car and hid it before calling for help.

Officers M.H. Mack and D.J. Aldridge responded to the scene, where they later found Freeman, who ran away after Marlow had fired on him. The officers arrested Freeman and charged him with assaulting an officer.

Then there are Freeman's versions.

In the statement he gave to police, Freeman says Marlow unlocked the car door and even opened it for him. Freeman says he got inside. After a brief moment, Marlow spotted a police car and told him to get out, thinking that the officer would question them.

Freeman then fully admits to attempting to extort Marlow by demanding twenty dollars to get out of the car. It was at this point that Marlow pulled out his badge and professed he was a police officer.

Freeman says he didn't believe Marlow because he could smell alcohol and thought it was unlikely that an officer would be driving around intoxicated.

"I could buy one of those," he said to Marlow in disbelief. "Maybe I'm a police officer, too."

Marlow pulled out his gun and shot at Freeman once. He then put the car in reverse and backed into a fire hydrant. Freeman snatched a couple of beers as he jumped from the car and ran. Marlow fired at him again as Freeman fled the scene.

Danny Watson offers yet another slightly alternate version of how things happened that night. He says Freeman told him and others that Marlow had solicited Freeman for sex and that the two were involved in the process when Marlow spotted the approaching officers. "He fired at ReRe to make it look like he was trying to escape," says Watson.

After eight days in jail, Freeman was released and all charges were dropped. Marlow immediately resigned and Mack and Aldridge were terminated. Their supervising officer, Sergeant Carl Boger, was given a thirty-day suspension for not properly investigating the incident.

Over the next few weeks, Freeman contacted an attorney to ascertain what his proper action should be against the city and the police department.

On April 22, he received a letter of apology from the police chief, which also included the police department's statement concurring with Freeman's version of his encounter with Marlow.

"He cried when he got that letter," his attorney, Nancy Walker, told the *Charlotte Observer*. "When it is his word up against a police officer, you'd expect them to believe the officer. He knew he was telling the truth and this confirms it."

During May and the early part of June, Freeman made it known to friends and acquaintances in the city's gay club scene that he planned to sue the city and the police department on grounds of assault, false imprisonment and civil rights violations. An *Observer* story reported that at varying times Freeman said his intentions were to use the money for a sex change, or to buy his own place and pay for drug rehabilitation.

Freeman was scheduled to testify June 12 as a witness in a hearing for Boger, who was appealing his suspension in regards to his handling of the incident involving Marlow.

"He was nervous about that," Watson recalls. "In fact he was very nervous. He admitted to me that he was afraid for his life."

Freeman would never get a home of his own, drug rehabilitation or a sex change. It was just five days before his scheduled testimony that he was gunned down, bringing to a close a life lived on the edge with untold dreams never fulfilled.

Despite the impending lawsuit, the controversy surrounding Freeman's arrest on January 8 and his scheduled testimony against Boger, police saw no correlation between the matters and Freeman's murder.

"This case is wide open," said Police Chief Darrell Stephens. "We don't have any definitive suspects. There are a lot of suspects—anybody who has had encounters with him."

To date, the case remains unsolved. Friends and family feel like Freeman's murder was simply swept under the rug, and the police department isn't doing anything to try and solve the case.

"We're doing everything we can to determine what happened," says Cold Case Investigator David Phillips. "But it's still an unsolved, cold case." Watson is adamant that Freeman's death was an inside job.

"I do believe that," he says. "It was so ironic. The weekend he was killed was the weekend before he was set to testify. How coincidental can that be?"

THE SOCIETY SLAYER

In the late 1940s, America was experiencing the beginning of the baby boom generation. The post–World War II mindset was happy and upbeat. Home construction, marriage and births were on the rise in Mecklenburg County and Charlotte's first television station went on the air on July 15, 1949. Viewers were watching programs like *The Lone Ranger*, *Ripley's Believe It or Not* and *The Voice of Firestone Theatre*.

But it wasn't happiness for everyone in mid-July of 1949.

Monroe Medlin had just been fired from his servant's job at the Esley Anderson Sr. home in Myers Park, reportedly for having a girl in the butler's quarters.

On August 1, 1949, at approximately 8:30 a.m., he returned to the Anderson residence, he later said, to retrieve some personal belongings left behind when he left so abruptly—a diary, army discharge papers and a scrapbook full of "girly" drawings he had collected while in the service.

He encountered the Anderson's new butler, Wilford Randleman, who told Medlin to leave. Medlin, apparently unable to retrieve his belongings, hid outside and waited for an opportunity to speak to Virginia Anderson, the sixty-eight-year-old wife of Esley O. Anderson, a wealthy and successful Charlotte-area businessman who owned and operated the Pyramid Motor Company. Mrs. Anderson was described in newspaper articles as a "fashionable socialite, wealthy matron and clubswoman."

Medlin managed to sneak past Randleman, who was washing dishes in the kitchen. He made his way upstairs, where he found Mrs. Anderson. She reportedly ordered him out of the house, while he attempted to explain why he was there. Unconvinced, she went to a nearby closet and retrieved her husband's shotgun and aimed it at Medlin.

"I told her I wasn't going to hurt her and to please not shoot me," Medlin later told police.

Medlin then attempted to take the rifle away from Mrs. Anderson. They struggled over the gun before she tripped over a rug; the gun discharged, shooting her just above the heart and killing her instantly.

Medlin panicked. He took eleven dollars from Anderson's purse and her car keys, because he intended to steal her car to escape the Charlotte area as quickly as possible. He took the rifle and got some additional ammunition from the closet because he realized he might encounter Randleman downstairs. He then headed to the dining room, where he stopped to reload the gun. He peered into the kitchen, saw no one and laid the gun down on the table.

At this point, his wife, Pauline Medlin, who was reportedly hiding outside waiting for her husband, entered the house through the kitchen. Medlin told his wife what happened and she told him that she had just seen Randleman go to the servants' quarters above the garage. She went upstairs and, while there, stole a jeweled wristwatch from a nightstand.

Monroe Medlin made his way to the servants' quarters, where he picked up a pipe and beat Randleman over the head. Pauline Medlin followed to the servants' quarters; upon discovering Randleman regaining consciousness, she reportedly slit his throat on both sides.

The two left the scene on foot, as Monroe Medlin later told the police. "I lost the keys to Mrs. Anderson's car somewhere in the house."

Less than thirty minutes later, a neighbor contacted police, telling them Randleman was lying in the Anderson's driveway, bleeding and moaning. He was taken to Good Samaritan Hospital.

Meanwhile, the authorities had discovered the remains of Virginia Shober Anderson sprawled in a pool of her own blood on the house's second level. Detectives rushed to the scene, and found fingerprints on the gun left behind on the dining room table and a lampshade. They are later identified as Monroe Medlin's.

Charlotte was terrified at the brutality of Virginia Anderson's untimely death. Residents of the Myers Park neighborhood—which was repeatedly referred to as "fashionable," "exclusive" and "upper-crust" by the local press—were outraged that such an occurrence could take place in their upscale section of town.

Less than twenty-four hours passed before Medlin was captured at a Second Street boardinghouse. According to police, he confessed "everything," including a statement that he slit Randleman's throat with a pocketknife. He later recanted and said that Pauline was responsible for cutting Randleman's throat.

Both Pauline and Monroe were arrested. He was charged with murder, she was charged with being an accessory after the fact. She was not charged

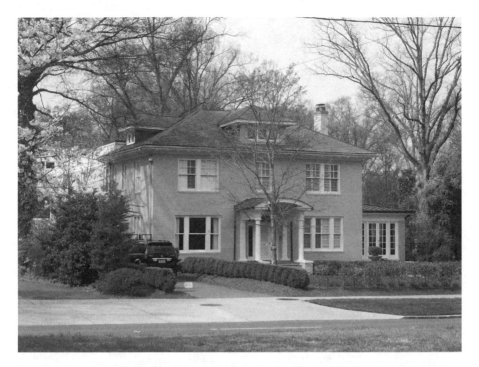

Scene of the crime: the Anderson family's former butler Monroe Medlin slit the throat of his replacement and then shot Mrs. Anderson in this house, which still stands today at 1128 Queens Road. *Courtesy of the author.*

with attacking Randleman, despite Monroe Medlin's assertion. Randleman later regained consciousness and said he had no recollection of his throat being cut. Surprisingly, he survived the ordeal, and later died at the age of eighty-four in 1990.

Esley Anderson Sr. died eleven years later at the age of eighty-four. Although he was surrounded by his son and daughter-in-law and two grandchildren in his later years, he never recovered from his wife's death.

Pauline was convicted of larceny and sentenced to ten to fifteen years in prison. Monroe was convicted by a jury of ten whites and two blacks for the first-degree murder and was sentenced to die in the gas chamber.

From the pages of Burlington, North Carolina's *Daily Times News*, dated December 9, 1949, less than three months after Virginia Anderson was found dead:

> *Warden Joseph P. Crawford said* [Medlin] *had told him he had made peace with the lord and was ready to go…Medlin struggled violently after inhaling the hydrocyanic gas, and the tube to the*

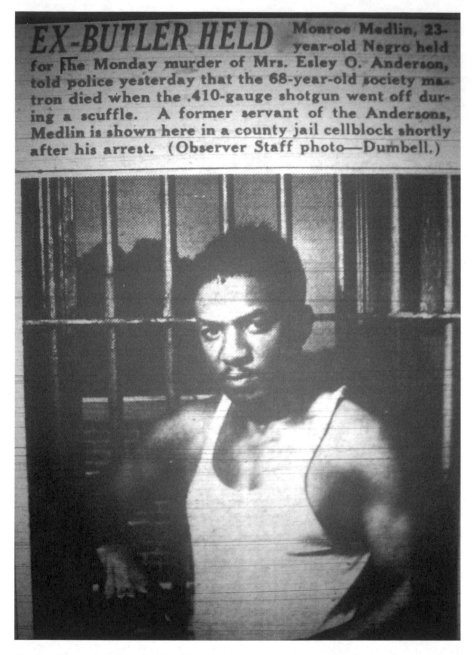

EX-BUTLER HELD Monroe Medlin, 23-year-old Negro held for the Monday murder of Mrs. Esley O. Anderson, told police yesterday that the 68-year-old society matron died when the .410-gauge shotgun went off during a scuffle. A former servant of the Andersons, Medlin is shown here in a county jail cellblock shortly after his arrest. (Observer Staff photo—Dumbell.)

Charlotte Observer headline showing Monroe Medlin after his arrest for the murder of society matriarch Virginia Shober Anderson.

stethoscope attached to his chest dropped off. Crawford said, however, that this tube was to record Medlin's breathing and the one recording his heartbeat was undisturbed so that no difficulty was experienced in determining he was dead. It required 11 minutes for the gas to kill Medlin. Medlin was pronounced dead at 10:53 a.m.

Twenty-seven people crowded the gas chamber to see Monroe Medlin die. Crawford said that Medlin's wife is in prison serving a sentence for larceny, his mother is in the Goldsboro hospital for the insane and his father died before he was born. His body was claimed by Greer Thompson Funeral Home of Charlotte.

Medlin's arrest records dated back to 1944, when at the age of seventeen he was charged with the theft of a bicycle. During World War II, he was sentenced to a year for violating the draft laws and was later released to be inducted into the army. While in the army, he was given a three-year sentence for being absent without leave (AWOL) and assaulting a noncommissioned officer. He was eventually dishonorably discharged.

When police searched the servant's quarters at the Anderson residence, they found a small book of thoughts in which Monroe Medlin had written the following words sometime before he was fired by Esley Anderson Sr.: "I am in [this condition] because of my friend, Mrs. [name not revealed]. [She] keep me in sad condition. O well, someone will find they [made a] mistake one day. I never have [had] a happy day of my life. Would be better off dead than I would be living."

SOLVED AFTER FORTY YEARS
The Starnes Case

There isn't much left on the piece of property designated as 3651 Mulberry Church Road. Save for a few caramel-colored glazed bricks, there's practically no evidence that a mid-twentieth-century ranch home once stood in the location and that two individuals shared their later years together here in what was once a cozy spot, surrounded by acres of mature pine and oak trees.

There's an old storage building that still stands at the very rear of the property—much older than the house itself—and probably part of another structure that once stood on the site when the area was vast farmland during the nineteenth century.

In the 1940s and 1950s, Mulberry Church Road and the surrounding neighborhood blossomed into a respectable working-class residential enclave.

All of that is gone now. The houses have been torn down and side streets razed over, mostly because of Douglas Airport's efforts to remove families that were too close to the frequent jet traffic overhead.

The house at 3651 was the first to go in the neighborhood, but it didn't have anything to do with redevelopment.

It sat empty for many years because no one wanted to live there.

A brutal double homicide took place in the home on the night of Monday, May 19, 1963.

The victims were an elderly retired couple—John and Annie Starnes —who purchased the home shortly after it was constructed in the early 1950s.

The Starnes had married young—John at just nineteen, and Annie at eighteen. A year after their marriage in 1910, they had their first child, a son named Paul. Five years later, a daughter, Vivian, would enter the world, to be followed by another daughter named Mary.

They raised their young family in Rutherfordton Township for many years, where John worked as an overseer at the local cotton mill. By the

1940s, all of their children had reached adulthood and John and Annie were at a crossroads: did they want to remain in Rutherfordton, where John could continue working in the mill, or was the pasture greener on the other side?

In an unlikely move for a couple of the time period, they decided to pick up roots and move to Charlotte, where John would open the Pilot Restaurant in 1949, across from the old State Highway Patrol Barracks on Wilkinson Boulevard.

Two years later, they purchased the home on nearby Mulberry Church Road.

Annie divided her time between caring for their home and the surrounding grounds she loved so much and helping out at the Pilot. The twosome developed quite a neighborhood following and would continue to run the business until sometime in the mid-fifties, at which point John took a managerial position at the Ambers Restaurant on Highway 29 North.

In the years that followed, John, now past retirement age, decided it was time to take a break. Now both he and Annie lived at the Mulberry Church Road home full time.

They spent their days together working in the yard, bird-watching and visiting with neighborhood friends, as well as going out on certain days for lunch at the City Luncheonette, also located on Wilkinson Boulevard.

Charles B. Wright, owner of the City Luncheonette, had maintained a friendship with the couple since they had moved to the area in 1949. In addition to serving up lunch and an occasional dinner for the couple, he also supplied John—an avid reader and voracious news hound—with his daily copies of the *Charlotte News* and the *Charlotte Observer*.

"He used to come in here every day for his newspapers, regular as could be," Wright recalled in an interview in the *Charlotte Observer*. "I saw him the last time on Monday, when he came in to get his afternoon paper. He left here, I guess, about 5 p.m. I didn't see him Tuesday because we're closed on Tuesdays. But Wednesday I saved him his morning paper and he didn't come by and get it at noon, like he usually did."

Wright continued: "When the afternoon came and he didn't come by, I got worried. I told my wife I was going to take the papers to the house, to see if he was alright, because I knew he'd been sick lately."

According to Wright, he arrived at the Starnes residence to find their car in the garage, outside and garage lights on and a television set blaring in the living room.

Wright was unable to get anyone to come to the door, so he returned to the restaurant, picked up a friend and made a second trip to his friends' house. Worried about his friends, Wright asked a neighbor to contact the police.

"I knew there was something wrong," Wright said. "It wasn't like John to leave the television set on or anything undone."

Indeed, something was very wrong inside the Starnes household.

Police were unprepared for the sight they would encounter when they entered the home on Wednesday, May 22, 1963, at approximately 5:15 p.m.

Blood was smeared on door frames and splattered on the walls amidst the telltale signs of a violent struggle. Lying on the floor of the master bedroom in pools of blood were the brutalized bodies of John and Annie. Both had been stabbed multiple times in the back and head with a weapon that made wounds about an inch wide.

Aside from a bureau drawer that remained open in the couples' bedroom, there was no evidence of robbery or anything to indicate the house had been ransacked. According to friends and neighbors, John and Annie Starnes were well liked and not thought to have had anyone who would want to see them dead.

So what was the motive? If not robbery and not revenge, what was the reason for the senseless, violent deaths of two retirees who were quietly living out their remaining years, disturbing no one?

"This is going to be a tough one," said then-police chief G.A. Stephens, after the first search failed to reveal any clues.

The county coroner determined that John and Annie had been dead for forty-eight hours. Police would later surmise that the attack had occurred late Monday night. Given the fact that the exterior lights were on, they inferred that, in all likelihood, John had perhaps heard something outside and flipped on the lights.

Once he opened the door to see what was causing the commotion, he apparently encountered a burglar, possibly a drifter not from the area —someone no one knew.

The individual, or individuals, forced John back into the house at knifepoint, demanding money or something of value. It's unclear as to whether he was fighting to prevent giving up something, or fighting to save his life and his wife, after it was determined the couple didn't have anything to give the perpetrators.

The case quickly went cold.

Less than six months later, a young drifter by the name of Luther Durham Jr., a native of Guilford County, North Carolina, was arrested and charged with breaking and entering, grand larceny, statutory burglary and first-degree homicide in the deaths of two elderly women in Richmond, Virginia.

According to Cold Case Detective David Phillips, police in Charlotte at the time noticed striking similarities between the two cases and immediately dispatched officers to Virginia to interview Durham.

At the time, Durham had not yet gone to trial for the homicide charges and simply told investigators that he might have information to share with them depending on the outcome of the case. If he was convicted, he'd have nothing to tell them. If he was acquitted in Virginia, he would be happy to return to North Carolina to share what he knew about the deaths of John and Annie Starnes.

On December 8, 1965, Durham was convicted on all charges and sentenced to life in prison plus fourteen years. Charlotte's police force knew their key informant would now be tight-lipped, and once again, the case went cold. This time, it would be forty years before the mystery behind the deaths of John and Annie Starnes would be solved.

The years passed and changeovers on the police force saw the Starnes case shuffled to the bottom of the pile and forgotten.

Then, after the *Charlotte Observer* produced a series of articles on unsolved murder cases, the Starnes case was reopened and a team of twenty-first-century investigators began to look at what information had been collected and left behind decades before.

Here, once again, they came across the name of Luther Durham Jr. Could he still be alive? Was he still in prison?

The detectives hit pay dirt. After an escape attempt in 1971, Durham was recaptured and was still being held. He was alive and well at the Bland Correctional Center in Bland, Virginia.

The Charlotte Mecklenburg Police Department (CMPD) once again reached out to Durham to see if, after the passage of so much time, he might be willing to tell them what happened to John and Annie Starnes back in 1963.

He was willing to talk. The story he told officially closed the case, but doubt still remains as to exactly who was responsible for their deaths.

Detective Phillips says that Durham recalled a late evening many years ago, when he, Alice Fritz (the girl he was purportedly dating at the time), her sister Myrtle Ward and their father George Monroe had been traveling through the Carolinas from Virginia. They were low on cash when they ran into car trouble somewhere along Wilkinson Boulevard. Durham indicated that George Monroe claimed he was acquainted with the Starnes and that perhaps they might be able to help out with some cash.

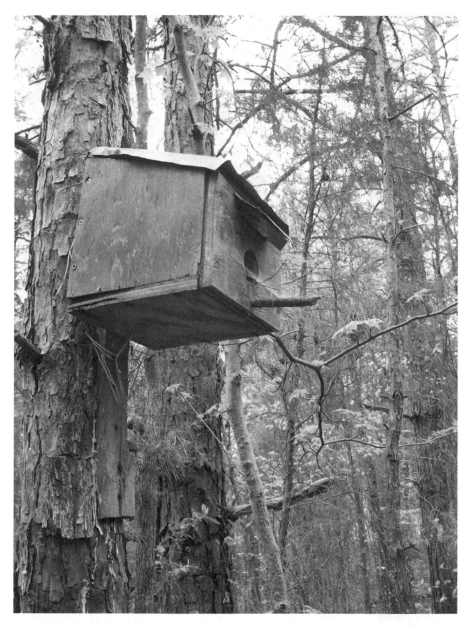

This page and next: After the murder of John and Annie Starnes in 1963, their property remained vacant for more than a decade. It was later bulldozed because no one wanted to live on the site of such a gruesome homicide. Today all that remains of the life they once shared here is an old birdhouse John probably hung for Annie and an ancient storage building on the far edge of the property that is being swallowed up by the advancing growth of foliage. *Courtesy of the author.*

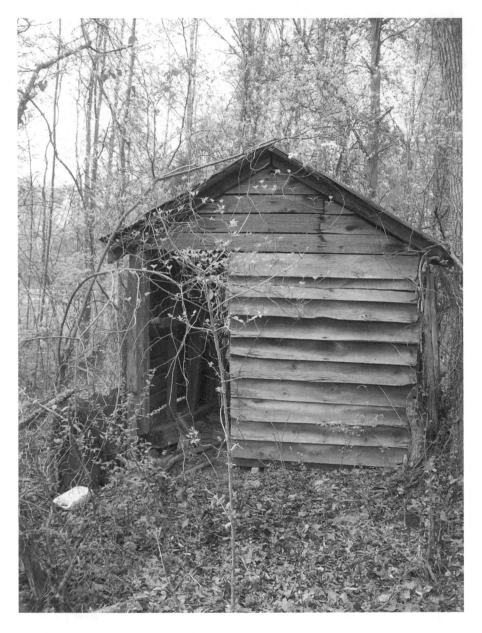

According to Durham, he managed to limp the car to the Starnes house, where he dropped Monroe and his two daughters off to talk with the elderly couple, while he backtracked to a nearby service station to see if he could find anybody on duty at such a late hour that might be able to help them. He told police he saw John Starnes open the door to his home and allow Monroe, Fritz and Ward entry.

After an unspecified amount of time, Durham told CMPD detectives that he returned to the Starnes home to pick up his friends. Upon arriving, he found John and Annie dead, and thought it best to get his friends as far away from the scene of the crime as possible, reportedly taking them out of state as soon as the car was repaired.

This scenario might hold water except for one fact: as of 2002, Monroe, Fritz and Ward were all dead, leaving no one to rebuff Durham's claims.

So the question remains—did Monroe and his family beat John and Annie to death, or was Durham responsible for their murders? Chances are, we'll never know.

Durham is serving a life sentence with no possibility of parole, according to Virginia authorities.

All that remains on the property that indicates two individuals once lived here and cared for each other is a birdhouse—probably hung by John for Annie so that she could enjoy watching the birds and take pleasure in the outdoor living she loved so much.

DID THE MILLIONAIRE KILL HIS MISTRESS?

Unlike many of the individuals examined in this book, George King Cutter *was* born with a silver spoon in his mouth. No obvious hardships here—only wealth and comfort.

The son of Gracie King and John H. Cutter, George was born in Charlotte on September 29, 1912. His father was one of the leading citizens of the city. An entrepreneur working in raw cotton, cotton textiles and real estate, John Cutter established the J.H. Cutter Company just after the turn of the twentieth century and was a member of the New York Cotton Exchange.

At the time of his death, in 1958, his accomplishments were too numerous to be listed here. Suffice it to say, J.H. Cutter was loaded when he passed on, and George benefited from that enormously.

Admittedly, it's impossible to know what kind of childhood George had. Did his parents push him to achieve beyond his means? Was he made to feel guilty because he didn't live up to the standards his clearly driven father had achieved? Unquestionably, his family was one that set extremely high standards.

A look at the family crypt in Elmwood Cemetery confirms the notion. Cut from hand-carved stone, it is the only such structure in all of Elmwood and serves as an everlasting monument to the Cutter legacy: one part business achievement, another part good citizenship and undoubtedly the mix of a third element—ego.

Although George tried to follow in his father's footsteps, he was reportedly hindered by a high libido and a penchant for alcohol. Both of these qualities tended to distract him from achieving his goals as early as his father had.

Did he pursue excessive drink and debauchery in an attempt to assuage wounds from his earlier life? It's impossible to know, but it's a distinct possibility.

Whatever the case, by his early forties he was a millionaire real estate developer who owned more property in Uptown Charlotte than any other single individual. Married to Nancy Bell, he was father to four children: George Jr., John H. Cutter II, Bryant W. Cutter and a single daughter, Linda Cutter.

In the late 1950s, he purchased an old postal bus that he had converted into what would today be called a vacation travel vehicle. Taking into account later media reports, it's possible he had another motive: a bachelor pad of sorts—reportedly complete with beds and a bar—that allowed him to be free to roam about and indulge in all his favorite vices.

In July of 1961, it appears his bad boy extracurricular activities finally caught up with him when he was accused of murdering his mistress, Delette Nycum.

According to reports in the *Charlotte Observer*, Cutter and Nycum —described as "attractive and pleasantly plump"—had maintained an affair since 1948. Their relationship had soured months earlier, but they continued to see one another when, on the evening of July 4, 1961, the two drove to Cutter's bus, which was parked in a storage building near the airport.

Cutter said that he had met Nycum at the bus, and that later, while she was sleeping, he had left for home. Worried about her being in such a remote location he later returned to the bus, and found her dead.

Millionaire businessman George Cutter had this bus retrofitted to serve as an apartment on wheels. *Courtesy of the* Charlotte Observer.

Recipe for disaster: booze, spiked heels and a mobile bachelor pad. *Courtesy of the* Charlotte Observer.

Because he wanted to avoid scandal, he said, Cutter somehow managed to convince Nycum's fifteen-year-old son Ricky to help place the body back in the house he shared with his mother at 2500 East Seventh Street and then tell police he found her there dead.

Delette Nycum's death was unusually gruesome. Literally beaten to death, the coroner would later state that she had died from "shock and external violence." A total of 251 bruises were found on her body.

When son Ricky called police to the residence, Cutter drove up and introduced himself as "a friend of the family." No doubt trying to make certain that Ricky got the cover story right, Cutter confessed that he had spent the night with Delette Nycum on the previous evening and even admitted to arguing with her and slapping her, but insisted he had nothing to do with her death.

Scene of the crime? Inside the bus where George Cutter claims to have found Delette Nycum's body. *Courtesy of the* Charlotte Observer.

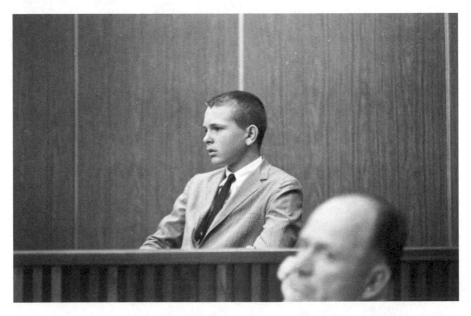

Delette Nycum's son testifies at George Cutter's trial. *Courtesy of the* Charlotte Observer.

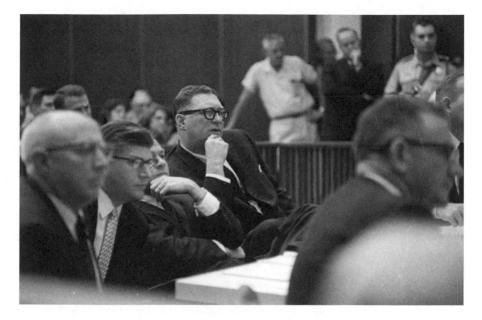

Above: Cutter (fourth from left) appears unfazed as jurors debate his fate. *Courtesy of the* Charlotte Observer..

Right: Final resting place: even though the court found the millionaire innocent, contrary public opinion, binge drinking and societal rejection led George Cutter to an early death just four years after the scandalous trial. *Courtesy of the author.*

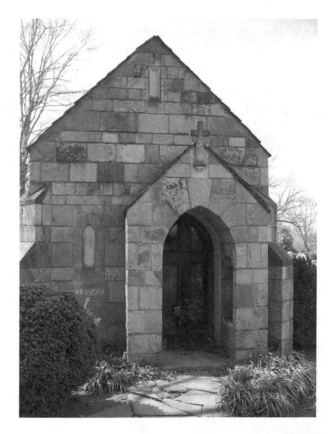

Police weren't buying Cutter's tall tale and eventually hauled him in and charged him with Nycum's murder. Denied bail, Cutter was forced to spend much of July, August and part of September in the county lockup before he went to trial on September 11. The trial that followed was nothing short of a Charlotte version of the O.J. Simpson spectacle that would occur three decades later.

The prosecution toted out witness after witness to testify against Cutter, including Ricky Nycum, Delette Nycum's maid Isabelle Cunningham, County Coroner Dr. W.M. Summerville, CMPD Lieutenant O.A. Crenshaw and Detective C.A. Allen.

The prosecution contended that Cutter kept Nycum in the bus for two days, where he slowly beat her to death. The defense maintained that her death was the result of alcoholism. The incident attracted so much attention it was covered in papers across the country and in *Time* magazine. A report in the *Raleigh News and Observer* confirmed that Cutter spent five hours in a brutal cross-examination, being questioned over and again about specific dates and times relating to his whereabouts and periods he spent with the victim.

In the end, despite mounds of circumstantial evidence, Cutter was found not guilty. His career, however, was damaged beyond all hope of restoration.

He lost control of the fourteen-story Cutter Building at the corner of Tryon and Fourth Streets that he was constructing at the time of Nycum's death and it was eventually renamed the American Building (it still stands today and is known as South Tryon Square).

His wife Nancy divorced him, and he later stepped down as the president of Cutter Realty. His final business dealings were as the owner-operator of the Farmhouse Restaurant in Belmont.

Four years after the trial, Cutter died at the age of fifty-three, rejected by Charlotte society. His body would be laid to rest in the family crypt in Elmwood Cemetery.

Delette Nycum's murder was never solved and the curious aspect of her son's collaboration with Cutter also remained in question. How could a middle-aged man successfully convince a teenage boy to help cover up the death of his own mother?

Some local residents say what they describe as "the Cutter family curse" didn't end there. George's former wife, Nancy Bell, later remarried Charlotte insurance consultant Adon Smith. In 1977, while vacationing with her husband in Tennessee, a three-hundred-pound boulder fell from a steep embankment and crashed into the couple's 1972 Cadillac, killing the former Mrs. Cutter.

OUTLAWS MOTORCYCLE MASSACRE

Much has been written about the Outlaws Motorcycle Massacre over the years, though it would be remiss to not include something about it here.

Referred to as the worst mass murder in Charlotte history, four members of the Charlotte chapter of the Outlaws motorcycle gang and a visiting friend were gunned down as they slept on July 4, 1979.

Locals who were in town for the holiday weekend that year recall the time as particularly uneventful, with next to nothing going on in the city and news coverage focusing on regional Independence Day celebrations.

The Outlaws story broke like wildfire.

According to police, the scenario probably went something like this: two suspects wielding a 9mm and a .223 semiautomatic fired approximately forty shots. A guard on the front porch of the house—William "Waterhead" Allen—was likely awake and talking to the suspects when they opened fire.

The four others inside the house—Outlaws members William "Mouse" Droneneburg, Randall Feazell, Leonard "Terrible Terry" Henderson and their friend, nineteen-year-old Bridgette Benfield—probably awoke to the sound of gunfire, but were unable to react quickly enough to escape. Police believe the massacre took less than fifteen seconds total.

The crime was discovered when William Kincaid "Chains" Flamont, the group's leader, arrived at the gang's clubhouse at 2500 Allen Road at 5:30 a.m. It was apparent there was something wrong immediately: Allen was dead on the front porch with multiple gunshot wounds to the chest. Flamont made his way through the rest of the house, discovering the bodies of the others, and then contacted Charlotte police.

Although the case remains unsolved, an article in the *Charlotte Observer* indicated that the murders were, in all likelihood, perpetrated by the rival Hells Angels motorcycle gang.

"They hate each other," said a police investigator in Detroit. "You just can't have them in the same city without all hell breaking loose."

At the time, the article said, Charlotte hosted both the Outlaws and the Hells Angels. In an effort to show Hells Angels members that the Outlaws were not afraid, a reported 150 members from gangs across the country poured into Charlotte for the funerals.

It is interesting to note that Flamont's own .223-caliber assault carbine was considered to be the probable weapon used in the shootings. It was left in the house on Allen Road the night before, but mysteriously vanished.

Flamont was apparently never considered to be a suspect in the case. Social Security records indicate that he died in Maiden, North Carolina in May 2001.

To date, the case is still open in Charlotte Police Homicide files.

CAMP GREENE

Sally Kennedy was her name. She was in her eighties when she would regale this author—then only a young boy—with tales of history and the strange goings-on in the sprawling wooded area just steps from her front door that was once known as Camp Greene.

Originally opened in July of 1917, Camp Greene was a U.S. military training facility designed to prepare soldiers for fighting in World War I. Located on the west side of Charlotte, the camp was constructed on 2,340 acres, a large part of which was the Dowd family farm. Today that area is bounded by Wilkinson Boulevard, Tuckaseegee Road, Ashley Road and Morehead Street.

Tens of thousands of young men from all over the country would descend upon Charlotte, causing the population to swell from a diminuitive twenty thousand to a staggering sixty thousand. Recruits for what was known as the Fourth Infantry Division would be deployed directly to Europe following their stint at Camp Greene.

Charlotte's city leaders had lobbied the U.S. government hard to be the site of the military training facility when it was announced that the search for potential grounds was underway.

World War I lasted around three years, so the facility was open a relatively brief period. During that time, promises made by the city to provide plumbing for sewage to allow for toilets and showers were never fulfilled, thus sanitary conditions became increasingly hazardous. During an influenza epidemic of the time, many soldiers perished. "There were so many sick young men," Sally Kennedy recalled. "So many of them. Thousands died."

Charlotte's Elmwood Cemetery serves as the final resting place for the many that perished and were either unclaimed or unidentified.

It's clear that conditions at the camp remained harsh year-round, regardless of the season. The winters were bitter. The summers were sweltering. Add

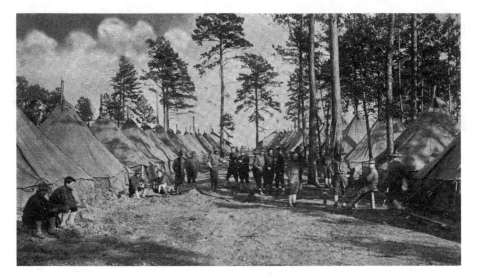

Soldiers relaxing outside their tents at Camp Greene. Within weeks they would be shipped off to battle in World War I. *Courtesy of the Robinson-Spangler Carolina Room—Public Library of Charlotte and Mecklenburg County.*

to that mix the lack of adequate sewage disposal plus a terrain composed largely of red clay and you had a large population of miserable soldiers.

A statement given to Congress in 1918 by New Hampshire Representative Sherman Burroughs summed up the dismal plight the recruits faced:

> *Camp Greene is located…on somewhat rolling ground of slight elevation and having a surface soil of clay formation. This soil is almost completely impervious to water, and the effect of melting snow and recent rains there has been to make it a veritable bog. Mud is knee-deep in all the roads throughout the camp. We had to wear rubber boots in order to get around at all. Water is standing in large pools and ponds all over the surface of the camp. No carriage or automobile could possibly get into the camp, much less make its way through it. I was informed by an officer that a few days before he had seen three mules so badly stuck in the mud that they had broken their legs trying to get out and had to be shot…There is not now and there has never been since the camp was established last summer any sewerage system whatever at Camp Greene. Dirty water from the kitchens and refuse of all kinds are thrown into ditches, and a good part of it remains there, because it can not get away and the clay soil will not absorb it. We saw a number of old discarded latrines. They*

Soldiers on kitchen duty at Camp Greene. Note the well on the right side of the photograph. *Courtesy of the Robinson-Spangler Carolina Room—Public Library of Charlotte and*

are still open and exposed and are filled with 6 or 8 feet of decaying, putrid, festering animal matter. When the warm weather comes, as it is likely to come any time in this southern climate, it takes no sanitary engineer or expert to predict what is going to happen. Flies are going to breed there in enormous quantities, and typhoid fever and diphtheria are likely to break out at any time.

According to an article published in the *New York Times* later that year, the military announced its plans to abandon the facility.

In the ensuing years, parts of the massive compound were dismantled and building materials were salvaged and used throughout Charlotte. Fortunately for the Queen City, many of the recruits who came to train for war opted to stay and make a life for themselves, keeping the population boom spurred on by Camp Greene intact.

These days, there's not much left of Camp Greene. At least not to the naked eye. There's the Dowd House, of course, which serves as a museum for Camp Greene, and an impressive monument that sits just a block away from the Dowd House on Wilkinson Boulevard.

It was decided to transform the grounds of Camp Greene into a public park during the late '80s and paved walking trails were added, directing the walker away from building remains that still stand throughout the area.

But if you stray from the path a bit, and look hard, you'll find some of the ghostly remains of what once was: bridge abutments that allowed soldiers to cross over long-since dried-up creek beds, wells where thirsty soldiers once quenched their thirst and decrepit concrete foundations that previously served as barracks, mess halls and officers' quarters.

"I can still see those young men right up here in my head," Sally Kennedy recalled. "Most of them were no more than eighteen, and I was already up in my late twenties by then. They seemed like such little babies, going off to fight war."

Sally would continue to live in the Camp Greene area for the rest of her life. Her husband Gus passed away in the early 1950s. It was not long after that she began to take notice of strange things happening in the forested area that covered what was left of Camp Greene.

"I saw lights. Strange lights. Late, late at night sometimes I'd be sitting out here on this front porch and I could peer through the trees and it looked like people carrying a lantern of some sort. Then there were the eerie sounds that would send a shiver up your spine. Somebody screaming in pain. Then sometimes it would sound like a crowd of people marching through the leaves."

Kennedy claimed she was always too scared to step off her front porch after dark, though she did once and wandered just in to the edge of the woods, What she says she saw there sent her running for the front porch, never to step foot off it again after sundown.

"It was misty outside," she recalled. "It was a strangely cool summer evening and it had rained earlier in the day. It was just a year or two after Gus had passed. He and I used to take walks in the woods together on nights like that, and it always smelled so clean after the rain."

Kennedy said she snapped off the upper half of one of the dried-up mullen plant stalks she kept on her back porch and set the top of it on fire, so she could use it as a torch to light her way. She was just feet into the edge of the woods when she saw something that made her stop dead in her tracks:

> *There was two young men several feet ahead of me on the path. They were covered in mud up to their waste. They were dressed in old clothes and one of them looked like he was hurt, because he was leaning on the other one pretty heavy. I wanted to help them so I tried to rush along as fast as I could to get to them. I lost sight of them at a bend in the path. When I got there, they were gone. They had just disappeared. I looked around in every direction, but I couldn't see a trace of them.*

This page: All that remains are an ancient well and a foundation from a former Camp Greene stronghold. *Courtesy of the author.*

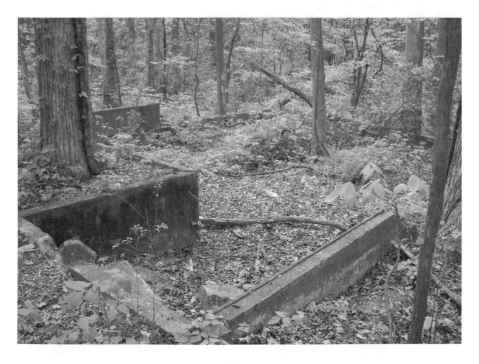

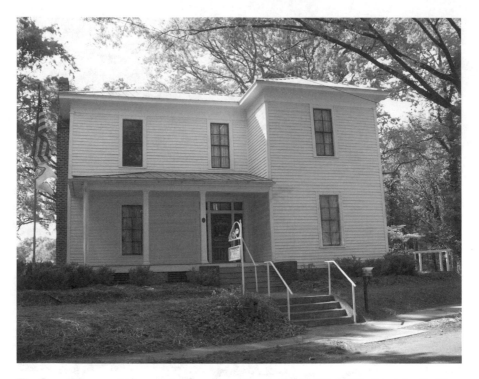

The Dowd House, which served as a command center for the World War I training facility, is the only preserved structure from the site. *Courtesy of the author.*

Then I heard that scream. It was the first time I ever heard it and it scared me enough to make me run for the house. I never went back in there after dark again, but every once in a while I would hear a scream that sounded a lot like the one I heard that night.

Sally Kennedy passed away in 1974 at the age of eighty-six. Her tiny house still stands on Granger Avenue just outside Camp Greene Park, and she and her husband Gus are buried in the city's Forest Lawn West Cemetery.

Portions of this article previously appeared in Charlotte Weekly.

MERCY

The Haunted Hospital?

L ocated just east of uptown in the Elizabeth Neighborhood, Carolinas Medical Center's Mercy Hospital is a 305-bed facility that provides a full range of medical care, from emergency room service and surgery to rehabilitation.

Aside from its amazing and advanced medical capabilities, the facility has a fascinating history, including some that might just indicate the presence of hospital visitors of another kind.

The hospital opened its doors in 1906, and the Mercy School of Nursing also opened that same year. Mercy's roots actually date back to Ireland and 1831, when a young woman named Catherine McAuley founded the Sisters of Mercy, a religious order that was freed from traditional church constraints that required nuns to work predominantly behind convent walls.

In the early 1900s, as Charlotte's population exploded to more than eighteen thousand, serious concerns were raised regarding the amount of available hospital care space. The pastor of St. Peter's Catholic Church, Father Joseph Mueller, came to the realization that the needs could be met with the aid of Belmont's Sisters of Mercy.

On February 26, 1906, Mercy General Hospital opened on East First Street in an old wood frame, two-story parish hall behind the church on Tryon Street. The facility was regaled at the time of its opening, but within just a few years, it became quickly obvious that it was far too small. Ten years after originally opening, Mercy moved to its current location on March 16, 1916. With seventy-five beds, a basement and three floors, it was described in publications of the day as "one of the most modern and up-to-date facilities of its kind in the state."

Over the next century Mercy Hospital would grow by leaps and bounds. In 1932, an additional wing added 35 more beds. Yet another wing was constructed in 1939, adding 40 more beds. In the late 1940s, after World

Mercy Hospital, sometime in the 1900s. This section of the hospital, where paranormal activity was reportedly observed by hospital employees, was torn down in 2007. *Courtesy of the Robinson-Spangler Carolina Room—Public Library of Charlotte and Mecklenburg County.*

War II ended, another 110 beds were added, raising the hospital's capacity for care to 260. By 1969, a Coronary Care Unit was established. During the 1970s, Mercy once again made the decision to expand by adding a new surgery suite, a dietary department, emergency room and more beds—this time its largest increase to date: 160 beds.

On June 5, 1995, the Sisters of Mercy sold the facility to Carolinas Medical Center. In the early 2000s, there were hopes to update the original Gothic-style building that faced Fifth Street but, disappointingly, it was determined that the foundation of the building was beyond repair and much of it was demolished.

"I remember working at Mercy when the nuns were in charge of the facility," says a staff nurse who would speak only on condition of anonymity. "And working in the original building that was torn down. There was so much that happened there, obviously, with such a large bed capacity and so many patients coming and going."

She continued: "Hospitals in general have a lot of negative and positive energy floating around. They're places where people are born and die and oftentimes battle painful and challenging illness. So there's a lot of energy left behind."

Many noted psychics believe such energy can be responsible for manifestations that some people see as spirits or hauntings.

"I've seen things," the nurse recalled. "In the old building that was torn down. Shadows moving, when there was nothing to cast them. Unexplainable sounds coming from empty rooms. Sometimes patients would complain. Once I remember a fellow employee who was working in one of the storage rooms in the old building. He came running out of the room late one night, claiming he'd seen something move towards him, but he couldn't tell who or what it was. He just said he was never going back in that room again."

With the construction of a new medical office in 2007 on the site of the original 1916 building, an unexpected discovery was made in an area that had been previously buried beneath the hospital: four gravestones and thirteen grave sites. The markers ranged in date from 1771 to 1778 and bore such names as Barnet, Bingham and Sprot. City records indicate that during colonial times the site was indeed the spot for the Sprot family burial grounds.

Accounts vary as to how the plots ended up beneath the hospital, but two possible scenarios exist: when the then-suburban lot for the hospital was originally purchased by Bishop Leo Haid in 1916, the former owners may have covered over the graves, as evidenced by the presence of twentieth-century fill dirt, simply for convenience's sake. The other theory that exists is that the graves were covered over in an effort to protect them and see that they remain undisturbed.

What lies beneath: demolition and reconstruction in 2007 at Mercy Hospital revealed that a family cemetery lay directly beneath the facility. *Courtesy of Ray Jones.*

Was it the spirits of these put-upon individuals, left underneath the very foundation of Mercy Hospital for ninety years, roaming the halls and calling out to be uncovered? Was it the energy impressions left behind from decades of tumultuous and cataclysmic emotional experiences, or perhaps the overactive imaginations of workers and patients running rampant from stress?

The answer remains unclear. Since the original building was demolished and the graves moved to Steele Creek Baptist Church, however, there have been no other disturbances reported.

Portions of this article previously appeared in the Charlotte Weekly.

PALMER FIRE SCHOOL
When Walls Speak

Driving on Seventh Street in Charlotte's Elizabeth neighborhood, you might have passed it, and you might have wondered about it: what exactly is that old stone building and the brick tower?

Bryan Barwick can tell you. He bought it back in 2003.

"It's a neat old building," Barwick beams. "The firefighters actually built it. All the stonework, they did—they hauled all the stones over here from an old tannery near downtown."

Completed in 1940, the Palmer Fire School was considered one of the best firemen's training facilities in the country. The building served as a training facility and a home for the Charlotte Fire Department's business and maintenance offices. Upstairs, the public could use a ballroom for receptions, concerts and dances, often hosting big name performers such as Cab Calloway.

Since the purchase, Barwick has restored the old Palmer Fire School and added two new buildings designed with similar period architecture that serve as medical and office condominiums. Administrative offices now occupy the lower level of the stone building while the upper original hall is available to the public for various functions.

Barwick's efforts to preserve the old while adding on with some new have been met with accolades from members of the surrounding community. It seems, however, that there might just be some longtime tenants of otherworldly nature who wanted to weigh in on the project, too.

During the restoration, one of Barwick's subcontractors, Sandy Woods, took some digital photos in the basement area.

"She called me a few days later and said I needed to see the images," Barwick recalls. Spaced throughout the photos were several circular globes of light, immediately recognized by the photographer as phenomena she'd read about—referred to by paranormal research specialists as "orbs."

If only the walls could talk—does the Palmer Fire School play host to spirits who've lost their way? *Courtesy of the author.*

"I am not saying…I do or do not believe in such things," Woods said in an email. "But I certainly could 'feel' things while in the basement area. I was never afraid, just touched by all the history that The Palmer Fire School represented."

Barwick and Woods were both hesitant to make any definitive claims, but the circular patterns of light are clearly present, with no discernible explanation for their existence in the darkened basement.

According to a number of resources that specialize in the paranormal, orbs are believed by some to be the "life force" of those who once inhabited a physical body on earth and have willingly stayed behind because they feel bound to their previous lives.

Beyond the orbs, another strange occurrence caught Barwick's attention. While work was being done on the interior ceiling of the ballroom, a small plastic tomahawk—a child's toy—was found lying in the inaccessible crawlspace between the roof and ceiling. Dating back to the mid-1950s, it's clear that the construction of the building predates the toy.

So how did it get there, and who was responsible for the act? Was it a favored object of some long-gone spirit who had fond recollections of the Palmer Ballroom and wanted to place the cherished memento there for safekeeping?

"I'm not saying this place is haunted," Barwick offers with a hesitant chuckle. "But I will say that sometimes…it feels like the walls are almost speaking to me."

Portions of this article previously appeared in Charlotte *magazine.*

BALL O' FIRE

The *Gastonia Daily Gazette* reported on June 18, 1937, that a "ball of lightning" crashed into the barn of the P.N. Slaten farm on the southwest side of Charlotte. "All of those in the barn and several cows were knocked down by the bolt, which they said resembled a ball of fire rolling around on the concrete floor."

An individual listed as Lloyd Edwards was treated at a local hospital for burns.

Nothing more is reported, but the question arises—what exactly is "ball lightning?" Many people dispute that it actually exists.

According to researchers of the phenomena, natural ball lightning appears infrequently and unpredictably. It may occur as rarely as only once every eleven years or so and may be directly related to sunspot activity.

Information on ball lightning and its occurrence in this region is scant—relegated mostly to a handful of twenty-first-century bloggers who claim to have been victims of its wrath in their childhood.

Around the world, however, there are a handful of infamous accounts.

The earliest recorded report occurred during a massive thunderstorm at a church in Widecombe-in-the-Moor in Devon, England, on October 21, 1638.

Four people died and approximately sixty were injured when an eight-inch ball of fire struck and entered the church, nearly destroying it. Large stones from the church walls were hurled into the ground and through large wooden beams. The ball of fire smashed the pews and windows, filling the church with a reportedly "foul sulfurous odor and dark, thick smoke."

According to the story, the ball of fire split in two, one exiting through a window by smashing it open, the other disappearing somewhere inside the church. The explanation at the time, because of the fire and sulfur smell, was that the ball of fire was "the devil" or the "flames of hell." Later, some blamed the entire incident on two people who had been playing

cards in the pew during the sermon, whom they say must have invoked God's wrath.

More modern reports of the phenomenon have also been uncovered.

Airplane pilots during the Second World War recalled strange sightings that may have been ball lightning. They described small balls of light that moved in varying patterns, which they would later refer to as "foo fighters."

Submarine crews during the same period often gave detailed recollections of small ball lightning occurrences inside the confines of the vessel. Frequent were the stories of ball lightning appearing when power cells, or "battery banks," were replaced, especially if handled incorrectly or when the highly charged motors were disconnected.

From Uppsala, Sweden, on August 6, 1994, comes a report of ball lightning that passed through a closed window, leaving behind a small round hole as evidence of its path. The occurrence was seen by a handful of Uppsala locals and was recorded by a lightning strike tracking system at Uppsala University's Division for Electricity and Lightning Research.

Depending on the report, ball lightning can move upwards as well as downwards, sideways, or in odd trajectories, such as rocking from side to side like a falling leaf. It can move with or against the wind or be more or less stationary in the air. It has been recorded in many different colors, sometimes even transparent or translucent. It is also sometimes said to contain radial filaments or sparks while others are evenly lit, and some have flames protruding from the ball surface. Its shape has been described as spherical, oval, teardrop or rod-like.

Additionally, it has sometimes been reported during thunderstorms, sometimes issuing from a lightning flash, but it is rarely described as occurring during calm weather with no storms in the vicinity. Some accounts say the balls are lethal, killing on contact, while other accounts claim that they are harmless.

That brings us back to the occurrence at P.N. Slaten's Farm.

According to area weather reports for June 17, 1937, the day and evening were described as fairly cloudy, with the temperature around eighty-seven degrees Fahrenheit and thunderstorms and showers were expected. Interestingly enough, a freak hailstorm reported earlier confirmed balls of hail as "large as the end of one's thumb" and extensive damage that ranged from destroyed convertible car tops to cracked and broken window panes and many destroyed plants.

"Hail stones varied so greatly in size and force when hitting the ground they would bounce as high as a foot or two," the *Gastonia Gazette* reported.

Clearly, conditions were ripe for atmospheric phenomena.

Was ball lightning responsible for electrocuted cows and workers at P.N. Slaten's farm? If so, the report may very well be the earliest known recording of its kind for Charlotte and Mecklenburg County.

THE CRASH OF EASTERN AIRLINES FLIGHT 212

It was barely after 7:30 a.m. on Saturday morning, September 11, 1974, when Eastern Airlines Flight 212 crashed just over three miles short of runway thirty-six at Douglas Municipal Airport. The plane was a DC9-30 carrying seventy-eight passengers and four crew members, operating on a scheduled flight from Charleston, South Carolina, to Chicago, Illinois, with an intermediate stop in Charlotte.

On that fateful morning, while conducting an instrument approach in dense ground fog, the aircraft met its fiery demise, killing seventy-one of the occupants. Thirteen people survived the initial impact, including the copilot and one flight attendant, who walked away with no serious injuries; however, three more ultimately died from severe burn injuries.

One of the initial survivors died of injuries twenty-nine days after the accident. Among the dead were the father and two older brothers of comedian Stephen Colbert; Charlotte physician Dr. Walter E. Noren; U.S. Navy Rear Admiral Charles W. Cummings, acting commandant of the Sixth Naval District; and three executives of the *Charleston News and Courier* and *Evening Post*: C.F. McDonald, circulation manager; Lewis Weston, production superintendent; and Jack Sanders, the mail room foreman. Also killed was John Merriman, news editor for Walter Cronkite's CBS evening news.

According to reports in the *Florence Morning News*, it was stewardess Collette Watson who walked away from the wreckage with only minor injuries. She was given medical attention and was released from a Charlotte hospital.

Another survivor, Robert Burnham of Charleston, said he thought he was thrown from the plane as it crashed.

"We were coming in and the pilot seemed to pick up power. It was real foggy. I felt one wing tip go down and then it hit some trees and I felt heat." Burnham said.

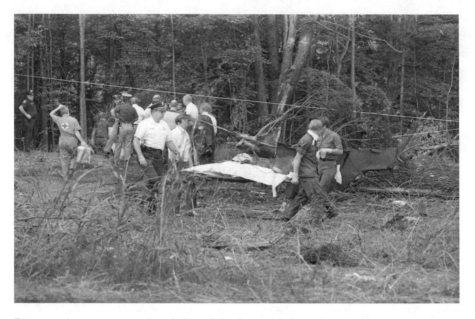

Rescue and recovery removing victims of the doomed jetliner. Among ninety-one passengers, only thirteen survived. *Courtesy of the* Charlotte Observer.

"I must have been thrown out of the plane. I got up, looked around and started running toward the woods."

Rescue workers found bodies and survivors scattered hundreds of yards from the plane. Pieces of clothing were found in the brush and trees.

Jim Stanley, who lived near the crash area, was one of the first persons to reach the wreckage. "The first thing I saw was people lying on the ground. This girl was lying beside the fuselage and had burns from head to toe, but she was alive," Stanley said.

"She was screaming real loud and I got sick. There was a man lying near her. His chest and his face were all messed up. I ran between the two burning sections of the plane. The ground was still on fire but it was burning down."

There's no question that the aircraft was destroyed by the impact and resulting post-crash fire. But what lead up to this event?

The accident was investigated by the National Transportation Safety Board (NTSB), which released its final report on May 23, 1975. Officials concluded that the accident was caused by the flight crew's lack of altitude awareness and poor cockpit discipline.

According to the cockpit voice recording, Captain James E. Reeves and First Officer James M. Daniels were engrossed in conversation and apparently paying scant attention to landing procedures:

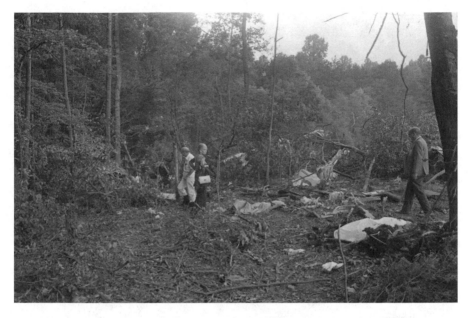

Wreckage from the crash sight of Eastern Airlines Flight 212. *Courtesy of the* Charlotte Observer.

Captain: Right. I heard this morning on the news while I was… might stop proceedings against impeachment [of the president].

[sound of altitude warning beep]

Captain: …because you can't have a pardon for Nixon and the Watergate people. Old Ford's beginning to take some hard knocks…
First Officer: We should be taking some definite direction to save the country. Arabs are taking over every damned thing…The stock market and the damned Swiss are going to sink our damned money, gold over there…
Captain: Yes sir boy. They got the money, don't they? They got so much damned money.
First Officer: Yeah, I think, damn if we don't do something by 1980, they'll [presumably the Arabs] *own the world.*
Captain: I'd be willing to go back to one…to one car…a lot of other restrictions if we can get something going.

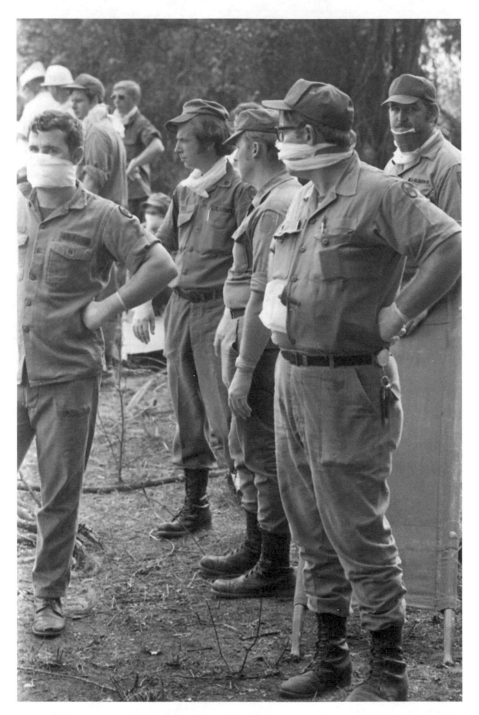

Tired rescue workers on the scene of the downed Eastern Airlines DC 9-30. *Courtesy of the Charlotte Observer.*

Five seconds before impact, the captain said, "Yeah, we're all ready. All we got to do is find the airport." The flight officer replied, "Yeah." One half-second later they both shouted and the DC9-30 crashed and exploded.

Most of the individuals onboard were residents of Charleston. Of the thirteen survivors on the plane, only one from Charlotte came out of the fiery DC-930 alive: Dr. William Shelley, the chief pathologist at Charlotte Memorial Hospital. His left leg had to be amputated and 50 percent of his body was covered in burns. Regrettably, it was Shelley who died twenty-nine days later.

As a result of the crash of Flight 212, the Federal Aviation Administration (FAA) would issue the Sterile Cockpit Rule, a regulation requiring pilots to refrain from nonessential activities during critical phases of flight. The policy was enacted permanently in 1981.

THE GUTHERY GOES UP
IN FLAMES

It was a time when America was witnessing the early progression of World War II. A total of 85 percent of citizens preferred to remain uninvolved and the country was still maintaining its neutrality, but not for long.

President Franklin Roosevelt had just extended social security benefits to everyone. Moviegoers were watching cinematic classics like Walt Disney's animated film *Pinocchio* and, more than two months after its opening, MGM's *Gone With The Wind*. Women were thrilled at the introduction of the nylon stocking and Charlotte hit a huge milestone that year: the population officially became 100,000, making the city the largest and most populous in the state.

In the early morning hours of March 13, 1940, another first would awaken residents of the Guthery Apartments at 508 Tryon Street in Uptown Charlotte: a massive fire, probably caused by a boiler explosion in the basement, which then swept through the three-story building.

Few people who walk past the old Tryon House Apartments in Uptown Charlotte today know the building's tragic history. Originally built in 1918, the building served as a fashionable yet economical in-town residential location for singles, young married couples and even small families at the time. A second, larger addition was added to the back of the building in 1926, making it stretch an entire block to College Street.

It was a bitterly cold morning and rain was pelting the streets when Charlotte Fire Chief Hendrix Palmer was awakened by the sound of a fire alarm.

"I knew the location of the box from which the fire alarm sounded," Palmer said in an interview with the *Charlotte News*. "I told my wife that may be the Guthery Apartments and I immediately began dressing. Before I had completed dressing the general alarm had sounded and my car from headquarters was at the door."

Before Palmer was even awakened, Edwin W. Hamer, an employee of Z.A. Hovis & Son, a funeral home less than a block away, was awakened by screams and calls for help. He looked out the window of the small apartment he maintained in the rear of the mortuary in the direction of the Guthery. He didn't see any flames, but he was certain something was wrong.

Hamer dashed from his apartment and cut across two back lots to get to the scene. By the time he arrived, thirty-two-year-old Etta Ely, a clerk at Effird's Department Store, was lying on the pavement of the driveway, having jumped from the third-floor apartment she shared with her husband, H.R. Ely.

Mr. Ely did not jump. Although he initially survived the blaze with severe burns, he died less than twenty-four hours later at St. Peter's hospital.

Two other unidentified individuals jumped and landed on either side of Hamer just before he and another man who happened upon the scene scooped up Ely and took her back to the funeral parlor. She was taken to the hospital later by ambulance, where she died of injuries sustained in the fall.

Lucy Walton, forty-three, was a private-practice nurse, although she would, on occasion, fill in at the Charlotte Sanatorium. She was sleeping soundly when she was abruptly awakened by the acrid smell of smoke and cries for help.

In a state of confusion, she rushed to the door and flung it open, causing a flash fire in the room as the oxygen-hungry blaze consumed her apartment. It singed most of her nightgown from her body before she dashed to her window, climbed on the bed and jumped to her death. Hamer confirmed that it was her nearly-nude body that hurled through the air and landed on the pavement beside him.

"If I hadn't jumped, I would have been alright," Walton later told attendants at the hospital, shortly before she died at 5:15 a.m.

Firefighters from around the county converged on the Guthery within minutes of the alarm, aghast at the horrific scene they encountered: men and women, screaming from ledges for help, some jumping to their death below when the flames drew too close.

The fight was made even tougher as firemen battled flames with water that would quickly freeze on the ladders they were attempting to use to rescue residents trapped on the second and third floors. Despite their attempts to convince frightened and confused individuals to wait for the ladders to reach them, residents continued to jump.

"A blond woman jumped out of a window when I was within a few feet of her," said fireman George Spittle. "I was at the next window rescuing another woman and I told her just to wait—that we would have the ladder

Nine people died in the calamitous fire that destroyed the Guthrie Apartments. Not many Charlotteans know that the building that was rebuilt from what remained was renamed the Tryon House, which is one of the few rental apartment buildings that exist in uptown Charlotte today. *Courtesy of the author.*

to her in just another minute. But as I started down with the other woman, she screamed and jumped."

The blond was Mabell Rockett, nineteen, who had just moved to Charlotte from Morganton only three weeks earlier. Rockett was taken to the hospital, although she never fully regained consciousness and died a few days later from injuries sustained in the fall.

A score of others would be injured that deadly evening and four others would perish in the fire, never even having the chance to make it out of the building.

Hazel E. Martin, forty-three, was the owner manager of the Hazel Martin Gift Shop. She perished along with her son Edward Martin, twenty-one. The two were found huddled in a small bathroom, with Edward attempting to shield his mother from the flames.

Rowena Dickinson, twenty-six, was found clad in a thin nightgown, kneeling by her bed. Her body seared by flames, she died of suffocation.

Tommy Charity, fifteen, was a freshman at Harding High School. He was found crouched in the corner of the bathroom.

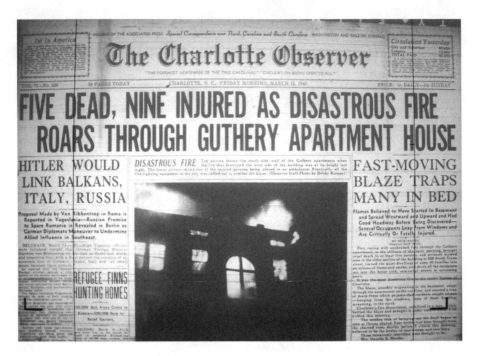

Headline from the *Charlotte Observer* announcing the tragedy.

Investigators on the scene at daybreak splashed through water-soaked floors and dodged rain falling overhead from the gaping hole left in the roof of the building by the inferno, which damaged every apartment in the front section of the building. Fire doors had closed off the newer rear section, leaving it completely untouched.

Much of the inner structure of the front was unstable and would have to be rebuilt before tenants could occupy that part of the building again. The Guthery family, owners of the apartment building, would begin rebuilding that section within a month.

Fire Chief Palmer offered his opinion that the fire did indeed start somewhere around the boiler room. When that happened, he surmised, the flames grew so hot that they melted two gas meters nearby, which then reacted like giant torches, sending flames up the elevator shaft from the basement to the top floor.

Inside the charred apartments, it was later discovered, the heat was so intense that aluminum cooking pots actually melted, leaving only their handles left hanging.

LOVE'S PASS

The headline across the top of the newspaper screamed in capital letters: "NINE KILLED AT CHARLOTTE CROSSING."

The date was December 26, 1931. Charlotte was celebrating the holidays and the upcoming arrival of the new year.

The nine individuals would never live to see 1932—Thomas Holton, his wife Susie, their two children Hugh and Marion and Thomas's brother Vaughn, along with Holton's uncle, Dorie Cox, Cox's niece Loma and family friends John Love and Raymond Sharpe.

The day began happily enough. The Holtons celebrated Christmas at their home in Charlotte's Paw Creek Township with their son and daughter and a visit later in the morning by Thomas's brother, Vaughn.

It was at the behest of neighboring farmer and Holton's uncle, Dorie Cox, that the Holtons, Love and Sharpe decided to travel to York, South Carolina, where Cox's brother Frank was throwing what promised to be a lively Christmas night square dance party.

John Love had just recently purchased the 1931 Ford Model A touring sedan and wasn't particularly enthusiastic about making the trip to York. He operated a nearby gas station and had become friends with many of the residents in the area. Dorie Cox and the Holton brothers were some of his very best friends. In fact, twenty-four-year-old Vaughn Holton, a mechanic by trade, often helped out around Love's filling station. Despite his reservations about the trip, Love didn't want to let his friends down. A single man running his own business at forty-two, it wasn't that often he had much of a chance to get out for an evening of fun, either.

Dorie Cox, fifty-seven, was a local farmer in Paw Creek and lived with his wife just a few miles from his nephew, twenty-nine-year-old Thomas Holton. A loom operator at Kendall Mills in Paw Creek, he and his family made their home in the adjacent mill village. Many of the residents of Paw Creek

and Thrift Townships made their living either through farming or working at Kendall Mills.

Life as a mill employee in the South in the 1930s could not have been a pleasant one. Long hours in a loud over-crowded environment that would have been subject to disparaging temperature changes—depending on the time of the year—most assuredly would have left Thomas exhausted.

Still, at the end of the day, he was always excited to come home to his young, twenty-two-year-old wife Susie, and their children—Hugh, five, and Marion, two. After a happy celebration with his family Christmas morning, the entire Holton clan was looking forward to the party at Uncle Frank's.

At just eighteen, Raymond Sharpe was already working hard at Kendall Mills in an effort to raise money to help with the care of his ailing mother. He was so excited about attending the dance with his friends John Love and Thomas Holton that he decided to wear a new necktie he received as a gift that very morning.

Barn dances (or an "Old Fashion Carolina Square Dance Party," as they were frequently referred to in rural North and South Carolina in the 1920s and '30s), were often popular forms of entertainment that could bring individuals together from different communities for fun and socializing. They would feature fiddle players turning out such hot numbers of the time as "Sailor's Hornpipe" and "The Virginia Reel." Dance callers kept the people on their feet all evening long with syncopated banter frequently rattled right off the tops of their heads but oftentimes borrowed from regionally celebrated callers, like this rhyming call from a well-known Southern "caller" of the day, Ernest Legg:

> *Ladies do and the gents you know,*
> *It's right by right by wrong you go,*
> *And you can't go to heaven while you carry on so,*
> *And it's home little gal and do-si-do,*
> *And it may be the last time, I don't know,*
> *And oh by gosh and oh by Joe.*

And for a party on a night like Christmas, it was sure to include lots of food and drink and open can fires to warm your hands by.

It was in this kind of environment that eight Paw Creek individuals would spend their final hours. After a long night of merriment, they decided to head for home. They were tired and it was well past the Holton children's bedtime, even if it was a holiday.

Murder, Mystery and Mayhem

Sometime just before midnight, they all piled in to Love's sedan. But this time another individual was joining in for the road trip back to Charlotte. Loma Cox, Dorie Cox's pretty and petite nineteen-year-old niece, had grown up in the Paw Creek area and was considered quite a popular young lady among her friends and suitors. Only recently had she left Paw Creek for York, when her parents decided to relocate there. No doubt Loma was looking forward to getting back to the roster of parties and gatherings that would continue throughout the holiday season, culminating on New Year's Eve and her upcoming birthday later in the month.

Without the ease of today's interstate highways, the drive from York back to Charlotte consisted of gravel, dirt roads and paved two-lane streets. It also took a good deal more time to travel from place to place. Most of the car's occupants probably dozed as Sharpe, the youngest adult and presumably the most alert at this late hour, trundled the rural roads towards home.

About an hour after their departure from York and within fifteen minutes of home, Sharpe was crisply handling the turns and curves of the rural Old Dowd Road with ease. Despite the cold temperature outside, the car's heating system kept its occupants toasty and comfortable inside.

With all the windows up, condensation had begun to form, making visibility somewhat difficult for Sharpe. He would realize the extent of his diminished viewing capacity only too late. At approximately 1:00 a.m., the Model A Ford sedan, loaded to capacity with nine occupants, passed over a railroad crossing at the precise moment that Southern Railway's Birmingham-to-Charlotte high-speed (or "crack") passenger train was rushing headlong into the final stretch for the inner city.

Moving westward as the train was northbound, the car drove into the crossing just as the fast-moving locomotive dashed from behind a cut of thick trees. With no red warning lights or barrier arms present like those that are used today, the approach of the train was not noticed by Sharpe. Since the windows were raised to fight off the cold and most of the passengers were asleep or dozing, apparently no one else in the car spotted the oncoming train.

According to reports in the *Charlotte Observer* and the *Charlotte News*, police summarized that in all likelihood, none of the passengers ever really knew what hit them. But the driver, for just one split second before his death, must have had some brief, horrific awareness of what was happening as tons of screeching metal ripped into the passenger side of the car and pushed it along for nearly two blocks before coming to a halt.

With the exception of Loma Cox, all the passengers were pinned in the car and their bodies were mutilated beyond recognition. Loma's

body had somehow become pinned to the front of the Birmingham Special's engine.

In an interview with the *Charlotte Observer*, Charles Sledge, a night watchman at the nearby Charlotte Pipe and Foundry Company, confirmed that he heard the crash, and rushed to the scene. When he arrived, the train, with the car pinned above the engine's pilot, was still rolling past him. He jumped from his car and ran alongside it until it came to a stop.

> *When I got there the train crew was getting out and they began to try and get the automobile off the front of the engine. It was terrible. I didn't stay but a minute or two after I got there. I saw the woman hanging on the front of the locomotive, and a man's head was sticking through the floorboard of the automobile. I could see the others piled up inside. It was so bad I left.*

Loma was the lone passenger in John Love's car to survive the crash—but only for a short while. Inside the automobile was a scene of ghastly carnage: a mix of bloodied and broken limbs and bodies.

From the *Charlotte Observer*:

> *All sustained injuries in the lower parts of their bodies, except the children, whose heads were crushed. The youngest child's body was mashed almost to pulp. Identification of the dead was difficult and it was several hours after the wreck before all of the dead were known. A key ring tag in the pocket of Love, bearing the name of John A. Love, route 5, Paw Creek, was the first clue. Officials of the Kendall mills at Thrift were communicated with by Ben E. Douglas, and in a short time Wilton Todd, manager, and W.F. Riddle, weaving overseer, came to Charlotte and identified all but Vaughan Holton and Miss Loma Cox. Later, I.S. Parker, night weaving overseer at the mill, arrived and completed the identification. Pathetic scenes occurred at the mortuary as relatives arrived to verify their fears. Cries of anguish and sobs of sorrow broke the stillness of early morning as they viewed the dead.*

Loma Cox was transported to Presbyterian Hospital, where she reportedly spoke a few words, but it was unclear if she ever fully regained consciousness. Sadly, the young girl who would never be able to attend that much-anticipated New Year's Eve soiree died on the table while being prepared for a blood transfusion.

It was noted in several reports from the time that at the same crossing on New Year's day, 1921, five members of the P.A. Deal family of Newton, returning from a funeral, were killed when their automobile was also struck by a locomotive.

The reaction from family members in the small, tightknit rural community was one of shock and horror.

John Love, the oldest sibling in a family of thirteen brothers and sisters, still resided at the family homestead just beyond Paw Creek. His seventy-year-old mother had taken the death of her first born very hard, according to John's sister, Margaret Love:

> She seemed to fear something was wrong, when he did not come home when we expected him. We did not go to bed, waiting for him. Mother kept insisting that something had happened to him, but we kept telling her she was silly to worry. Except for my father, who died two years ago, we have never known death intimately. We just did not realize that it could happen like that. Just like blowing out a candle.

The Loves had their worst fears confirmed when a younger brother of Raymond Sharpe came to inform them of the disaster. The Sharpes and Loves were close friends—the Sharpes had a telephone, the Loves did not.

Members of the Sharpe family told reporters that Raymond had left home with his father on Christmas evening, sometime around sundown. He was excited about the dance, and looking forward to spending time with friends.

Raymond's critically ill mother, physically unable to leave her home, was devastated by the death of her son, who was a graduate of Paw Creek High School and a top basketball player on the school's team.

An older son of the Sharpes had died suddenly at about the same age in years prior. "He was at camp with the Boy Scouts, and had to have an operation suddenly. He died under the ether before any of us could reach him. That makes this harder for his mother," said Raymond's father.

Relatives of the Holtons were overwhelmed by the sudden erasure of an entire family in a single instant. "It just doesn't seem possible. I can't believe it," Thomas Holton's father said. "The two children had such a merry Christmas. [They] were just the right size to take a mighty pleasure in Santa Claus."

As for Dorie Cox's wife, she had spent Christmas day with her mother, and was unaware of the events that led up to her husband's death. The news of the early morning tragedy was brought to her by a brother-in-law. Grief-stricken by the news of the loss of her longtime companion, she was further devastated by the death of the Holtons.

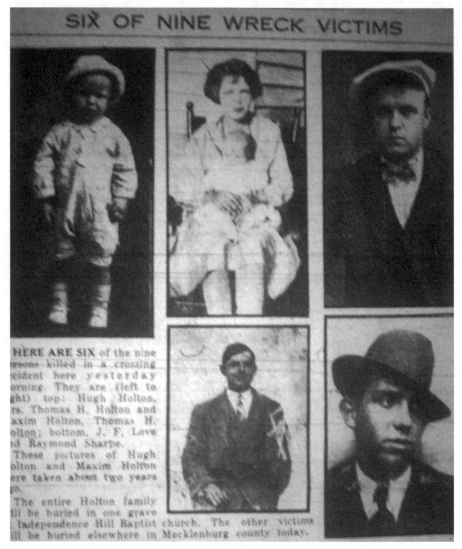

SIX OF NINE WRECK VICTIMS

HERE ARE SIX of the nine
rsons killed in a crossing
cident here yesterday
orning. They are (left to
ght) top: Hugh Holton,
rs. Thomas H. Holton and
axim Holton, Thomas H.
olton; bottom, J. F. Love
id Raymond Sharpe.
These pictures of Hugh
olton and Maxim Holton
ere taken about two years
go.
The entire Holton family
ill be buried in one grave
Independence Hill Baptist church. The other victims
ill be buried elsewhere in Mecklenburg county today.

Headlines from the local paper show the victims of the horrific disaster. A similar incident took place at the same site in 1920.

After receiving a wire that their daughter had been killed, Loma's parents, John and Alice Cox, rushed to Paw Creek at 11:00 a.m. that Saturday morning. They did not know until their arrival that Dorie and their nephews had been killed in the crash, as well.

The following information came from a report in the *Charlotte News*. It's clear, given the descriptions, that traditions surrounding death have changed a great deal since 1931:

Murder, Mystery and Mayhem

The mortuary of Douglas and Sing, which handled the victims of the tragedy was packed all day, as hundreds of friends and relatives viewed the victims. Close friends and relatives cried aloud with horror at the broken and distorted remains of those they loved. Sheets over the bodies had to be changed time and again as the telltale stains of blood seeped through. Up to a late hour Saturday the funeral chapel was crowded with relatives and friends, making funeral arrangements.

Perhaps because of the nature of the disaster that befell their loved ones, or maybe because embalming was not as common in 1931 as it is today, all nine of the victims were buried within twenty-four hours of the disaster.

All five of the Holtons were buried together in a single grave site and eulogized in one ceremony. Their headstones can still be viewed today at Independence Hill Baptist Church on Eastfield Road in Huntersville.

John Love, Dorie and Loma Cox are buried very close to one another near the front center of Paw Creek Presbyterian's sprawling historic cemetery.

Raymond Sharpe's funeral rites were held at his home so that his mother could attend. He was laid to rest shortly thereafter at what is today known as Moore's Chapel United Methodist Church. He is surrounded by brothers and sisters, his father and his beloved mother.

Following the services and burials, the tragedy spurred a movement to either move the train pass, or offer some other more reliable means of warning automobile drivers of its impending passage through the area.

City Councilman John F. Boyd insisted that the council should immediately consider plans for the elimination of the crossing.

"I am well acquainted with the officials of the Southern railway and I believe we can do something to do away with the crossing," Boyd said in the pages of the *Charlotte News*. Mayor Charles Lambeth and Councilman T.T. Allison both felt that a twenty-four-hour watchman service should be maintained there, though they had not given any thought to the question of eliminating the crossing.

Another councilman echoed Boyd's sentiments. "I regret the existence of conditions that would result in such a terrible tragedy," said Councilman Claude Albea. "I would be anxious to support any measure that would eliminate such conditions anywhere in Charlotte."

"The matter has not been taken up with the council and no thought has been given to the Dowd road crossing," added City Manager J.B. Pridgen. "Some people do not regard this as a dangerous crossing, but I do and always have."

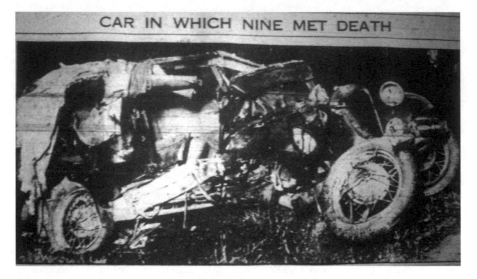

CAR IN WHICH NINE MET DEATH

From the pages of the *Charlotte Observer*: the twisted wreckage of John Love's 1931 Ford Model A.

At the time of this book's publishing, the train crossing that claimed the lives of nine on a fateful early morning over seventy-five years ago remains largely unchanged. There are markers with the traditional "RR" symbol perched above a red light that is intended to warn drivers—but even now there are no guard arms. Some residents of the area today claim that the red lights often began to flash when there's no evidence of any train for miles around.

One man, eighty-one-year-old George Jones, a lifetime resident of the area and the owner of Jones Hardware, recalls a lot of talk about the accident, but adds that he has very little firsthand recollection. "I was just a little boy," he recalled. "I think was around four at the time it happened. But I knew all of the relatives of the people that were killed in the crash. It affected so many people around here. Not many of the people who were directly connected to any of the victims really ever got over what happened that night at Love's Pass."

THE CHARLOTTE
LOUNGE FIRES

It was a time that began with bell-bottoms, toe socks and platform shoes and ended with feathered hair, disco and the nation's bicentennial celebration. Charlotte was struggling with school desegregation and the country was growing weary of the Vietnam War as Republican Richard Nixon finished up a first term as president and began an ill-fated second.

Patrons of the city's local nightclub scene were watching their entertainment opportunities shrink by the month.

Over a five-year period in Charlotte, from 1971 to 1976, numerous nightclubs throughout the city were torched systematically, all using a similar method of soaking the club's interiors with kerosene or gasoline. Among the businesses to be burned were the Purple Penguin, the Scorpio Lounge, the C'est Bon, the Carrousel Lounge, the Soul Train and a host of others. In total, there were seventeen. Investigators determined that all, except for one, were set intentionally.

Local nightclub owners were fearful of a so-called "protection racket" that was extorting business owners for money so they wouldn't be burned out. Others suggested that rival bar owners were simply trying to squash competition and that it got out of control.

"Okay…here it is. It is an absolute fact," says a bar owner who spoke with the *Observer* on condition of immunity. "[I know who] burned down my lounge. I can't prove it because I wasn't there when he did it, but believe me, I know he did. And it is an absolute fact that he burned down his own lounge. He joked with me after he did it. He said, 'There's no way they'll catch me unless you tell them, and if you do, you're next.' But if [I told] you those names they'd come burn down my house. And if I'm in it they'll burn me, too."

Officials in the Charlotte-Mecklenburg Fire Department and the police department both agreed that they were confident about possible suspects, though evidence to prove their theories was sorely lacking.

"We can be almost certain who set some of these fires," said then-captain J.C. Davis. "But getting the kind of evidence we need for a conviction has been tough."

"These people in the lounge business are scared," said John Knowles, a fire inspector for Mecklenburg County. "They say if they talk to us somebody is going to burn their homes or hurt their families."

Perhaps it's only a coincidence, but it should be noted here that brothers John and Michael Plumides were connected in some form or fashion to at least four of the fires.

According to the *Charlotte Observer*, the Plumides brothers were owners of the C'est Bon Club on Central Avenue, owners of the building that housed Flashes Lounge on Orr Road, which was the scene of two fires—one on July 15, 1974, and another on November 4, 1974—and owners of the building that housed the Stallion Lounge on Tryon Street.

Until August 21, 1975, no individuals had been hurt during any of the fires that occurred. The Stallion Lounge was the scene of two deaths. The building was soaked in gasoline and then consumed by fire within minutes.

The charred remains of two teenage boys were discovered just inside the rear door. One of them, sixteen-year-old Tony McKee, was the son of the lounge's owner, Joyce McKee, and the manager, David McKee.

Police were uncertain as to whether or not the youths set the fire or were caught at the scene at an inopportune moment.

To date, almost all of the fires remain unsolved.

THE SECOND WARD
TROLLEY DISASTER

On Thursday, March 26, 1931, America's First Lady Lou Henry Hoover drove through town on her way to see her son in Asheville, where he was recuperating from tuberculosis.

Easter weekend was just a week away and JCPenney was touting stylish ankle-strap shoes for just $2.98. At motion picture houses, moviegoers were watching William Powell in *Man of the World* and Adolph Menjou in *Men Call it Love*. On the radio fans were listening to such entertaining programs as *Amos 'n Andy*, *Sisters of the Skillet* and *The Tastyeast Jesters*.

Cars were becoming increasingly affordable for everyone—a top-of-the-line Ford Model T could be purchased for $630.

But that was still out of range for millworkers, domestic servants and day laborers, many of whom toiled at the bottom rung of Charlotte's working class, and were forced to use the city's trolley service to get back and forth to work.

No doubt some of those on board Charlotte's Second Ward streetcar had caught the first few minutes of *Amos 'n Andy* during its 7:00 a.m. broadcast just before heading out the door to hop the car that was bound for Biddleville.

Behind the controls of the streetcar was conductor J.F. Shoemaker, an affable fellow who always welcomed his passengers onboard with a smile and a friendly greeting.

A large number of the riders were mostly African American women, like Marie Johnson and Ola Etheridge, who made their living as housekeepers for some of the wealthier families that lived in and around the downtown area. Other passengers included day laborers and millworkers, like Joe Faulkner and Sam Robinson. In total there were forty-nine individuals along for the early morning ride. The trolley had already passed through Independence Square and was just about to make the railroad track crossing on West Trade Street.

Heading into Charlotte around the same time that morning was Southern Passenger Train No. 11, going southbound from Danville, Virginia, to Greenville, South Carolina. The early morning train, which carries businessmen bound for Atlanta and families visiting relatives at stops along the way, was packed to capacity and on time for its 7:30 a.m. pass through Charlotte.

On a trip they had made so many times before, it had been an uneventful morning and business as usual for Conductor J.A. Sifford and Engineer C.M. Martin. All of that was about to change.

"I was standing with the motorman on the Second Ward car when we stopped at the lowered gates to allow a handcar of section men to pass northbound," R.H. Callahan told the *Charlotte Observer*.

> *The gates raised and we started across the tracks. A store on our left blinded the view of the tracks to the north. Halfway across the tracks I heard a bell start ringing and at that moment I saw a southbound train roaring down the track.*
>
> *The motorman seemed to try to reverse the car but it was too late and he had no time. For five seconds I stood appalled as the train bore down on us. The passengers broke into screams of terror. After an awful rending crash, I had a nauseating sensation of floating through space, as if hurled at great velocity, and then I was knocked unconscious. I must have fallen through the door of the trolley and slid several feet on the pavement.*
>
> *The watchman evidently did not see the train approaching from the north and raised the gates when the tram car passed along from the south.*

According to various accounts in both the *Observer* and the *Charlotte News*, the train locked its wheels in an attempt to stop but simply did not have the time. Within seconds, the long passenger train slammed into the trolley, pushing the forty-ton streetcar aside like a child's toy.

From the *Observer*: "The street car was crushed in the middle, hurled off its track to one side and every pane of glass was shattered. Several of the screaming passengers were thrown through the windows."

W.B. Hollingsworth, a cabdriver who was on hand at the train station, told the *Charlotte News* that he saw panic-stricken passengers in the trolley screaming and yelling and attempting to move about inside the car away from where it appears the train would collide with the streetcar.

43 INJURED AS TRAIN CRASHES TROLLEY

This image from the cover of the *Charlotte Observer* shows a crowd gathered around the twisted trolley car following its collision with a passenger train on the morning of March 25, 1931.

When the collision occurred and the trolley was pushed from it tracks, passengers were hurled in every single direction. Ola Etheridge was thrown through a shattered window and clear of the tracks. She sustained head injuries and was in a state of shock. Marie Johnson was tossed from the car through the boarding door, breaking an arm and also sustaining head injuries in the process.

Sam Robinson suffered severe lacerations to his right side, dislocated his shoulder and was left with extensive visual impairment from shards of window glass that landed in his eyes.

Joe Faulkner was thrown from the trolley directly into the path of the oncoming train, which rolled over him, severing his right foot.

Of the forty-nine passengers onboard, a total of forty-three individuals were injured, some severely, but no fatalities were reported.

Although integration was present on the trolley, segregation and the Jim Crow mindset still reigned supreme throughout most of the South during this period and the Queen City was no exception. Despite the fact that Charlotte considered itself an enlightened city, segregation still existed in neighborhoods, schools, public facilities, churches and hospitals.

As was customary for the day, African Americans were treated at a hospital designated solely for blacks. Twenty of the passengers onboard—all the African Americans injured—were transported to Good Samaritan Hospital. The remaining injured were treated at St. Peters, Presbyterian Hospital and the Charlotte Sanatorium.

According to recovered records, blame for the incident was never fully assigned. But the accident, no doubt, would be one of the final nails in the coffin for the city's trolley system. Almost seven years to the date of the crash, the service was discontinued in the city, replaced by a bus system and the continued success of the individually owned motorcar.

CIVIL RIGHTS BOMBINGS
Hatred Explodes

On May 17, 1954, the landmark court case *Brown v. Board of Education* ruled that segregating public schools was a violation of the Constitution. The ruling set in motion changes that would affect access to education across the country, though it would be sixteen years before Charlotte would properly integrate their own school system.

Throughout much of its history, Charlotte has been perceived as very much a nonconfrontational kind of city. Cultural and civil changes were slow to arrive because so few people wanted to stand up and make the move to push things forward.

In 1957, three years after *Brown v. Board of Education*, four African American high school–age students decided to test the ruling. As America looked on, the teenagers arrived at some of Charlotte's all-white schools as angry crowds gathered around to protest. In the tense times that followed, people spat on Dorothy Counts at Harding High School. They called Gus Roberts names at Central High. At Alexander Graham Junior High, they shunned Delois Huntley. At Piedmont Junior High, they did the same thing to Gus Roberts's little sister, Girvaud.

Three more years would pass when, in 1960, African American students from Johnson C. Smith University formed a sit-in at a "whites only" lunch counter at Charlotte's Kress store. Mayor James Smith responded by forming a committee to solve the problems of segregation and soon thereafter lunch counters were integrated.

By 1965, however, schools in Charlotte remained largely segregated. In January of that same year, Darius and Vera Swann decided they wanted their son, James, to attend school near the family's home. But since the Swanns were black, James was assigned to an all black school farther away. The NAACP and attorney Julius Chambers filed legal action against the Charlotte-Mecklenburg Board of Education.

Days later, Chambers found himself in a firestorm of controversy.

On January 25, 1965, a dynamite blast destroyed the car that belonged to Chambers. Three men were eventually convicted of the bombing in New Bern, North Carolina, and one was identified as the head of the Ku Klux Klan in that area. All were convicted and given suspended sentences.

Luckily, Chambers was unhurt, but there was more violence to come.

As the case was argued in court, unknown perpetrators opposed to school integration were plotting to put a stop to efforts by Chambers and the NAACP.

This time they took aim at four of Charlotte's civil rights leaders: Chambers; State NAACP President Kelly M. Alexander; his brother City Councilman Fred D. Alexander; and Dr. Reginald A. Hawkins.

Between 2:15 and 2:30 a.m. on the morning of November 23, 1965, explosions rocked the houses of the four men, all on the west side of town. No one was injured, though flying glass came dangerously close to slashing Hawkins's two children. The most destruction was done to the homes of the Alexander brothers, which were located next door to one another. Considerable interior and exterior damage was evident. The bombs' impacts were somewhat less extensive at the homes of Chambers and Hawkins—but the mental impact was just as strong.

Police stated that the perpetrators used sticks of dynamite.

"It was a well organized group," said Chief of Police John Hord. "I guarantee you it was people who knew what they were doing. Whoever it was, they knew the explosives, they knew the sections and they knew how to get in and get out quickly."

"Anytime four blasts happen like this, it's organized," NAACP leader Kelly Alexander said in the pages of the *Charlotte Observer*. "I don't know who organized it," but it was an organized force trying to kill us."

Although Chambers's car was bombed earlier in the year, he didn't see any connection between the incident in New Bern and this one. "I can't link it with anything," he said. "I don't know anything about it. I wish I did."

Said Councilman Alexander of the individuals responsible for the explosions: "They were experts. They did a complete demolition job."

Hawkins, whose home was fired upon eleven times the previous August after he testified in a school desegregation case, was confident about who was responsible for the attacks. After that incident, he received a phone call claiming responsibility. "They called and said it was the Ku Klux Klan. I don't have any doubt it's the same people here."

The reaction from Charlotteans was not unlike response to other racially motivated crimes in the past: shock, guilt, embarrassment and a desire to

reach out and help. Instead of arousing further violence, citizens rallied around the victims.

Community leaders were concerned about how the incident portrayed Charlotte and North Carolina. "We cannot allow anyone to resort to lawlessness and violence—North Carolina's continued progress depends on the maintenance of law and order," said Governor Dan Moore.

Mayor Stan Brookshire organized a relief fund and raised money to repair the houses. He urged Charlotteans to attend a racial harmony rally the following week. "A large and representative audience will tell the world that Charlotte will not be deterred in its efforts to promote racial harmony and community progress through the fullest possible development of responsible citizenship." A crowd numbering in the thousands showed up for the event.

The fight for desegregation would continue another five years when, in February 1970, Federal Judge James McMillan issued a ruling saying that desegregation must begin right away. Within a few weeks, students of all ages were bussed throughout the Charlotte Mecklenburg School System, and black and white children finally had equal access to a public education.

Some parents complained, but school desegregation in Charlotte was finally an undeniable reality.

An added footnote: one year later, attorney Julius Chambers's office on West Tenth Street is burned to the ground. Like the bombing in 1965, no one was ever convicted of the crime.

WHEN A LYNCH MOB RULED CHARLOTTE

To say that Charlotte in 1913 was a far different place than it is today is an understatement.

Construction on suburban neighborhoods like Myers Park and Dilworth had only begun just two years earlier. The downtown area's first skyscraper —the Independence Building, topping out at twelve stories—was just barely five years old.

In the country at large, the population had just elected Woodrow Wilson president and the world is less than a year away from what would later come to be known as World War I.

In North Carolina seven years earlier, in 1906, a lynch mob in Rowan County had attacked and killed three African American men, all for purported killings for which they were never taken to trial. Three other men also arrested in conjunction with the same crimes were spared when they were moved to Charlotte for safekeeping.

Until 1913, that was Charlotte's only brush with mob killings, or lynchings, as they were often referred to. No other records exist and city leaders claim that no such heinous incident had ever before occurred in the Queen City.

That changed on August 26, 1913, when an angry mob of thirty-five men dragged Joe McNeely from his hospital bed at Good Samaritan hospital and forced him out into the streets, where he was fired upon more than twenty times.

On August 21, McNeeley was arrested for the shooting of Charlotte Police Officer L.L. Wilson.

The fact that a law enforcement agent had been shot, and the fact that his supposed attacker was a "colored" or African American man, was outrageous for many of the traditionalist Southern separatists who made their home in and around Charlotte at that time. For these individuals, the

due process of law was not fast enough to curb their anger. A lesson had to be taught. The man had to pay for what he had done.

What apparently riled the mob into action was that McNeeley, who had been shot during the exchange with the policeman, was in better condition and recovering from his wounds faster than Officer Wilson.

Throughout the day on August 25, there had been rumblings that a mob might be forming to take the matter into its own hands. Two messengers came to Sheriff Wallace around 11:00 p.m., explaining that he might expect trouble. He immediately communicated with the police department, asking that an investigation be made. Headquarters reportedly assured Wallace that no trouble seemed to be afoot and all was quiet. The decision was made that the two guards on hand watching over McNeeley—C.E. Earnhardt and T.L. Tarleton—would be sufficient protection.

Sometime about 1:30 a.m., staffers at Good Samaritan realized they were in trouble when it was noticed that a large number of men appeared to be congregating outside the facility.

A woman identified only as a "Negro nurse" in a story published in the *Charlotte Chronicle* later testified that a gang of men with rags and cloths wrapped around their faces appeared at the front door of Good Samaritan and demanded to speak with Officer Earnhardt.

The nurse reportedly refused them entry, saying, "You will not get in this house tonight," as she quickly locked the door behind her and Officer Earnhardt dashed to a telephone in an attempt to call in more policemen.

Their efforts were futile, however, as the angry mob broke through the front door and swarmed into the building, guns and pistols aimed at Earnhardt, who had already pulled out his gun but immediately had it snatched away. Some of the men began to make their way to the room on the second floor where McNeeley was being held.

"I was held in a corner," said Earnhardt, in an interview with the *Charlotte Daily Observer*. "With a pistol on each side of my face and three men guarding me, I knew I stood no chance as there were 20 or 40 men in the room."

Officer Tarleton—who was still on the second floor just down from McNeeley's room—later testified that he, too, had attempted to get to a telephone when he noticed the crowd of men ascending the stairs. They stopped him in the stairwell, shoving pistols in his face, immediately confiscating his weapons and holding him at bay while they broke into McNeeley's room and dragged him from his hospital bed, practically nude, and into the streets.

Both officers say they demanded and then pleaded with the masked mob to spare McNeeley's life, but also conceded that against such a large,

armed crowd, and having been stripped of their weapons, they were virtually powerless.

As the crowd surged past Earnhardt with McNeeley and out into the night, the members of the mob that had been subduing Earnhardt rejoined the crowd and left him unattended.

"They quickly had [McNeeley] outside, and the three men who were guarding me left. I followed them," said Earnhardt. Twenty or more shots rang out before Earnhardt made it outside to the spot on the ground where McNeeley's crumpled body lay.

According to Tarleton, the entire attack was done and over in about three minutes. No one else in the hospital was injured and the perpetrators scattered in all different directions simultaneously in an effort to distance themselves from Good Samaritan as quickly as possible.

Amazingly, McNeeley initially survived the attack, sustaining seven shots—four to his arm and three to his torso.

"I stayed with him," Earnhardt recalled. "I never left him until aid arrived."

Unfortunately, McNeeley did die later that morning, about 5:00 a.m.

Reaction to the mob attack from the governor and a presiding judge ranged from shock and horror to embarrassment and outrage.

"The persons who committed this crime," said Governor Locke Craig, "will be prosecuted and punished to the limit. All good citizens will do their part to avenge this outrage against the law, which was trampled down by a

Joe McNeely was taken from this facility, Good Samaritan Hospital, and executed by an angry mob of thirty-five on August 26, 1913. The Bank of America Stadium occupies the land today. *Courtesy of the Robinson-Spangler Carolina Room—Public Library of Charlotte and Mecklenburg County.*

band of criminals in the dark. The officials at Charlotte are awake to the situation and will not rest until members of this lawless mob are brought to justice."

"There walks today upon the streets of your city 35 men, according to the accounts, who are actual murderers," said Supreme Court Judge J.T. Hall. "The deed they did was dishonorable and cowardly and it is imperative they be brought to justice."

Following the mob attack, a report appeared that sometime later in the night, the Myers Park Hardware store was broken into, and a quantity of pistols were taken, along with sufficient ammunition to match the number of arms.

Fears arose the following day that some kind of armed reprisal was being organized, and the hospital was placed under heavy armed guard. Many private individuals showed up to offer their support in guarding Good Samaritan, and most remained until the wee hours of the morning.

According to all reports, none of the witnesses were able to identify any of the attackers. "Not a ray of light has been shed on any identity of a member of the mob," the *Charlotte Daily Observer* reported. "And there seems scant prospect that any incriminating information will be obtained."

The *Observer*'s assertion was correct. Mob members closed ranks and grew tight-lipped. No one was ever convicted for the death of Joe McNeeley, and the men responsible went to their graves with the secret.

As a direct result of the slaying of Joe McNeeley, the Charlotte Police Department purchased their first automobiles to be used as police cars, pointing out that had they been in place already, their speed would have allowed officers to respond and possibly prevent McNeeley's murder, and at the very least aided them in capturing the perpetrators.

BIBLIOGRAPHY

THE SAGA OF BENNY MACK

Charlotte Observer. "Boxer Faces Trial Today; Negro Later," February 26, 1929.

———. "Ex-Pug Is Charged In Bank Robbery," April 1, 1961.

———. "Mack Sentence Is Made Limit After Cursing," February 28, 1929.

———. "Price Declares First Shot Hit Moore In Back," February 27, 1929.

Danville Bee. "Ex-Boxer Held In Marion, N.C. Bank Robbery," April 1, 1961.

———. "Mack Trial For Slaying Begins Today," February 26, 1929.

Fresno Bee. "Ex-Pugs Play Thugs," January 7, 1962.

Landmark. "Benny Mack Says He Was Railroaded," March 4, 1929.

———. "Judge Stack Scores Prize Fighting," February 28, 1929.

Oakland Tribune. "Prizefighter Sought By Federal Agents," October 17, 1933.

Robesonian. "Judge Stack Preaches Lay Sermon In Sentencing Killer Benny Mack," March 4, 1929.

RAZOR GIRL

Charlotte Observer. "Defense To Claim Razor Slayer Has Mind Of 6-Year-Old Child," July 13, 1926.

———. "Jury Acquits Nellie Freeman," July 22, 1926.

———. "Razor Slayer Is Arraigned," July 13, 1926.

Creative Loafing. "Razor Girl: A Halloween Tale From Another Time," October 25, 2006.

THE MAUSOLEUM MURDER

Burlington Daily Times. "Rites Slated For Victim Of Murder," September 22, 1959.

Charlotte News. "Ex-Convict Hunted In Slaying," September 23, 1959.

———. "Grim Discovery Made Lasting Mark On Boy," September 21, 1959.

———. "Police Hold Hot Suspect In Death Of Aged Widow," September 22, 1959.

———. "Probing Of Murder Continues," September 26, 1959.

———. "Victim Is Found In Tomb," September 21, 1959.

Charlotte Observer. "Charlotte Winos Vanish From Usual Haunts," September 24, 1959.

———. "City Police Free Suspect In Murder," September 24, 1959.

———. "Coroner Says She Was Raped," September 22, 1959.

———. "Man Crouched Near Bench Where Widow Sat," September 24, 1959.

———. "Officer Says 'Everybody Is A Suspect,'" September 25, 1959.

———. "Police Press Hunt For Widow Killer," September 22, 1959.

———. "Slain Widow's Body Found In Mausoleum," September 21, 1959.

United States Court of Appeals. *Elmer Davis Jr. v. State of North Carolina*. United States Court of Appeals Fourth Circuit Transcript, April 28, 1966.

———. *Elmer Davis Jr. v. State of North Carolina*. United States Court of Appeals Fourth Circuit Transcript, December 8, 1964.

———. *Elmer Davis Jr. v. State of North Carolina*. United States Court of Appeals Fourth Circuit Transcript, June 7, 1962.

Franklin Freeman: Who Killed ReRe?

Charlotte Observer. "Chief Punishes At Least Three In Fracas," June 21, 2002.

———. "Reckless Lifestyle, Unsolved Death," June 30, 2002.

———. "Slain Man Got Apology Over Tussle With Officer," June 14, 2002.

———. "Transvestite Found Shot To Death Near Uptown," June 9, 2002.

Creative Loafing. "Franklin Freeman Autopsy Revealed," October 16, 2002.

———. "Franklin Freeman Won't Go Away," July 17, 2002.

Bibliography

The Society Slayer

Associated Press. "Negro Condemned By Mixed Jury," September 5, 1949.

Charlotte Observer. "Former Butler Says Struggle Over Gun Cause Of Fatal Shot," August 3, 1949.

———. "Police Seek Killer In Anderson Slaying Case," August 2, 1949.

Chester Times. "Former Butler Admits Murder of Socialite," August 2, 1949.

Daily Times-News. "Gas Snuffs Out Lives Of Three Convicts," December 9, 1949.

Landmark. "Medlin Formally Indicted In Killing," August 9, 1949.

———. "Negro Says He Took Gun From Mrs. Anderson," August 4, 1949.

Statesville Daily Record. "Ex-Butler Arrested In Anderson Murder," August 2, 1949.

———. "Medlin Accuses Wife In Killing," August 8, 1949.

———. "Slayer's Wife Will Be Jailed," August 3, 1949.

———. "Two Murderers, Burglar Gassed," December 9, 1949.

Solved After Forty Years: The Starnes Case

Charlotte Observer. "I Thought I'd Take His Newspaper To Him," May 23, 1963.

———. "Man And Wife Found Slain At Their Home," May 23, 1963.

DID THE MILLIONAIRE KILL HIS MISTRESS?

Charlotte News. "251 Bruises Counted On Victim's Body," July 5, 1961.

————. "Cutter Renews Building Battle," June 16, 1962.

————. "Millionaire Faces Hearing In Widow's Death," July 5, 1961.

————. "Family, Friends Shocked At Mrs. Nycum's Death," July 5, 1961.

Charlotte Observer. "George King Cutter Found Dead At Home," January 7, 1965.

————. "Falling Boulder Hits Car, Kills Insurer's Wife," January 28, 1975.

Greensboro Daily News. "Charlotte Builder George Cutter Slated To Go On Trial Monday In Slaying Woman," September 10, 1961.

Mecklenburg Times. "Cutter Faces Trial For Life In September," August 3, 1961.

————. "Cutter's Case Will Be Given To Grand Jury," July 27, 1961.

————. "Cutter's Trial Scheduled For September 11," August 31, 1961.

————. "Downs To Ask Special Venue In Cutter Case," August 10, 1961.

————. "George Cutter A Good Inmate," August 31, 1961.

————. "Lawyers Oppose News Cameras in Court Rooms," July 27, 1961.

Raleigh News and Observer. "Cutter Becomes Confused About Dates Under Cross Examination," September 17, 1961.

OUTLAWS MOTORCYCLE MASSACRE

Charlotte Observer. "Gang Rivalry Points To Big Biker Funeral," July 5, 1979.

————. "Outlaw Killers Fire On Cue, Police Believe," July 5, 1979.

BIBLIOGRAPHY

CAMP GREENE

Charlotte Weekly, June 2007.

MERCY: THE HAUNTED HOSPITAL?

Charlotte Weekly. "A History of Mercy Hospital," January 2008.

PALMER FIRE SCHOOL: WHEN WALLS SPEAK

Charlotte. "When Walls Speak," July 2003.

BALL O' FIRE

Gastonia Daily Gazette. "Five Charlotteans Hurt By Shock," June 18, 1937.

THE CRASH OF EASTERN AIRLINES FLIGHT 212

Charlotte Observer. "Jet Crash Kills 69," September 11, 1974.

Danville Bee. "Charlotte Crash Kills Many," September 11, 1974.

THE GUTHERY GOES UP IN FLAMES

Charlotte News. "Guthery Fire Claims Eighth Victim," March 18, 1940.

———. "Six Persons Die, Eight Others Hurt As Fire Sweeps Through Guthery," March 15, 1940.

———. "Six Victims of Fire Well Known In City," March 15, 1940.

Charlotte Observer. "Death Toll In Guthery Fire Stands At Seven," March 16, 1940.

————. "Five Dead, Nine Injured As Disastrous Fire Roars Through Guthery Apartment House," March 15, 1940.

————. "Score Rescued From Inferno," March 16, 1940.

Cumberland Sunday Times. "Twin Beds Are Twin Funeral Pyres," March 17, 1940.

Fresno Bee. "Apartment Fire Kills Seven In North Carolina," March 15, 1940.

LOVE'S PASS

Charlotte News. "Death of Nine At Crossing Stirs Leaders," December 27, 1931.

————. "Rites Are Set," December 27, 1931.

————. "Tragedy Spurs Move To Abolish Fatal Crossing," December 27, 1931.

Charlotte Observer. "One Big Grave To Hold Family Wiped Out In Collision Here," December 27, 1931.

Danville Bee. "Nine Killed At Charlotte Crossing," December 26, 1931.

THE CHARLOTTE LOUNGE FIRES

Charlotte Observer. "Charlotte's Lounge Scene Going Up In Flames," September 1, 1975.

THE SECOND WARD TROLLEY DISASTER

Charlotte News. "43 Injured In Train Car Crash," March 26, 1931.

———. "Train Hits Car Filled With Passengers," March 26, 1931.

Charlotte Observer. "28 Are Still In Hospitals As Result Of Street Car Wreck," March 27, 1931.

———. "43 Injured As Train Crashes Trolley," March 27, 1931.

———. "Street Car Passengers Tell How It Feels To Be In Wreck," March 28, 1931.

CIVIL RIGHTS BOMBINGS: HATRED EXPLODES

Charlotte News. "Police Handcuffed In Bomb Probe," November 26, 1965.

Charlotte Observer. "After Bombings, Nation Saw A Different Charlotte," November 24, 1965.

———. "Bomb News Flashed Across U.S.," November 23, 1965.

———. "Council Says Indignantly—'Rebuild,'" November 23, 1965.

———. "Interracial Rally To Be Held Sunday," November 25, 1965.

———. "Law Agencies Mass To Probe Bombings," November 23, 1965.

———. "Police Seek Leads In Home Bombings," November 24, 1965.

———. "Repudiate Bombings—Mayor," November 27, 1965.

Creative Loafing. "Charlotte's Tour of Infamy," September 28, 2005.

WHEN A LYNCH MOB RULED CHARLOTTE

Charlotte Chronicle. "Negro Shot By Mob," August 26, 1913.

Charlotte Daily Observer. "Majesty of Law Trampled Upon By Mecklenburg Mob," August 26, 1913.

ABOUT THE AUTHOR

David Aaron Moore has been writing as long as he can remember. Since 2005, he has penned the ongoing serial fiction column "Elmwood Park" for *Uptown* magazine. His work has appeared in *Atlanta* magazine, *Charlotte* magazine, *Creative Loafing*, *Charlotte Weekly*, *Swing* and *Banktown*, just to name a few. He has interviewed such celebrated personalities as Hugh Grant, John Travolta, Lily Tomlin, Tammy Faye, Grace Jones, Melissa Etheridge and Nancy Sinatra, among many others. Over a fourteen-year-period, he's worked as an editor and writer for a number of publications, including Atlanta-based *Jezebel*; Window Media's *Southern Voice* and the *Washington Blade*; and Pride Publishing's *Q-Notes*. A lover of history and mystery, Moore is just as likely to be found digging through historical archives as he is kicking around forgotten cemeteries.

ALSO AVAILABLE

Wicked Charlotte: The Sordid Side of the Queen City
Stephanie Burt Williams
978.1.59629.160.7 • 96 pp. • $19.99

Bootleggers, swindlers, gold miners and serial killers—Charlotte has courted them all. The Queen City is a flourishing Southern metropolis, but just below its polished exterior lies a dark past full of crime and myriad misdeeds. This underground history of Charlotte has been concealed and denied by those who retell the city's story and by those who have lived it. Until now.

Visit us at
www.historypress.net